IMAGES
of America

GUILDERLAND
NEW YORK

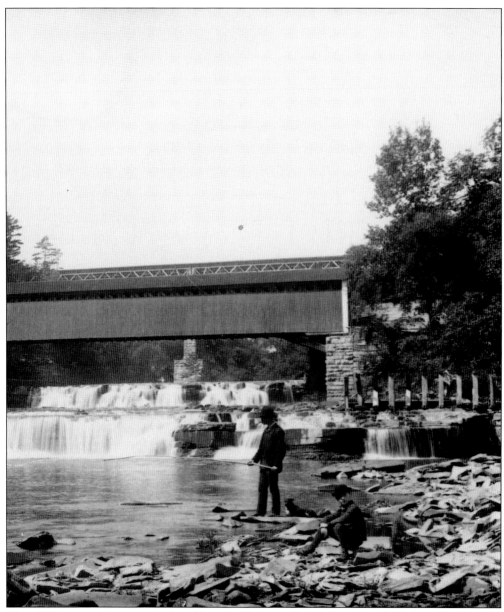

This 1880 scene, photographed at Frenchs Hollow, shows the covered bridge spanning the waterfalls and two Guilderland residents enjoying the sun and a little fishing. Swimming was a recreational treat in the cool, clean waters of the Normanskill.

IMAGES
of America

GUILDERLAND
NEW YORK

Alice Begley and
Mary Ellen Johnson

ARCADIA
PUBLISHING

Copyright © 1999 by Alice Begley and Mary Ellen Johnson
ISBN 978-0-7385-0112-3

Published by Arcadia Publishing
Charleston SC, Chicago IL, Portsmouth NH, San Francisco CA

Printed in the United States of America

Library of Congress Catalog Card Number: 9960798

For all general information contact Arcadia Publishing at:
Telephone 843-853-2070
Fax 843-853-0044
E-mail sales@arcadiapublishing.com
For customer service and orders:
Toll-Free 1-888-313-2665

Visit us on the Internet at www.arcadiapublishing.com

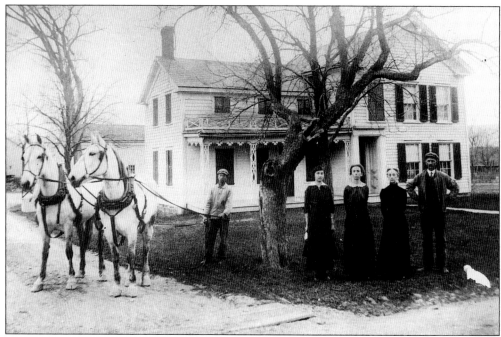

The Will Mynderse Farm at 151 Main Street in Guilderland Center was typical of the 1890s era. John Wormer stands with his team of horses while Mabel Tullock, Mrs. Tullock, Mrs. Shannon, and Andrew Tullock look on. The house still stands on Route 146, across from the Mynderse-Frederick House.

CONTENTS

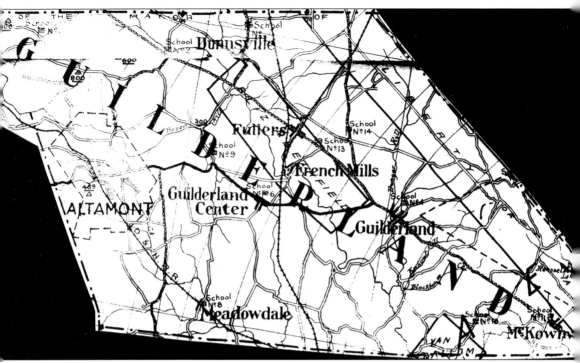

Shown here is an 1890 map of Guilderland, New York. Note that Meadowdale, Dunnsville, and Frenchs Mills were equally as important at that time as Altamont, Guilderland Center, and McKownville. Westmere was not in existence then.

INTRODUCTION

Winston Churchill wrote, "Without a sense of history, no one can truly understand the present." Looking at the town of Guilderland through photographic images brings to life the people and events that have shaped our town and allows us to visualize the time when simple farm areas and close-knit hamlets formed the landscape. This collection of photos from the Guilderland Historical Society and various other contributors permits us to present a different perspective of our town today. The photographs record Guilderland's history from the 1880s to 1960 and pay tribute to the people and achievements that have shaped Guilderland as we know it.

Hundreds of years ago, before Guilderland existed, bands of Mohican Indians camped and hunted along the Normanskill Creek. This turbulent stream harbored Mohican and Mohawk canoes as they slipped quietly downstream to the Hudson River to trade at the Dutch trading post. The resources of good soil, waterpower, and timber that could be found at the banks of the Normanskill and at the foot of the majestic Helderberg escarpment encouraged the Dutch magistrates to begin making land deals with the Mohicans. The area became a part of the Manor of Rensselaerwyck under the Patroonship of Killean Van Rensselaer. Throughout the Revolutionary War, sturdy pioneer families moved west to this outlying area, establishing farms along the waterway and paying rent to the wealthy patroon.

Since its pioneer days in the 1700s and its formal beginning in 1803, Guilderland has been a historic and unique locale. On February 10, 1803, Nicholas V. Mynderse proposed a petition to the State Assembly requesting that 58.67 square miles of land be separated from Watervliet, yet remain part of the Van Rensselaer Manor. The town was established on April 3, 1803, and named Guilderlandt after the Province of Gelderland in the Netherlands, the birthplace of the first patroon. Mynderse was elected as the first supervisor.

When the rural community organized itself into the first township of Guilderlandt, Thomas Jefferson was President and the Union flag boasted 15 stars and 15 stripes. The Louisiana Purchase was the first territorial expansion of the new nation, and Lewis and Clark had just begun their Northwest Expedition.

Historians note that the first improved highway heading west was the old Schoharie Road between Albany and Schoharie. It passed through Hamiltonville (Guilderland), Guilderland Center, and Altamont. Inns, taverns, and small farmhouses sprang up along this route that preceded the Great Western Turnpike, which was

completed in 1799.

In the 18th century, only a few people lived in the eastern section of Guilderland, an area of scrub pine and sandy soil laced by ravines and streams. William McKown, a later town supervisor, built a tavern on the border of the city of Albany, where the Kings Highway stretched through the Pine Bush toward Schenectady. The Palatine Germans marched from Albany southwest to Schoharie, crossed the Normanskill, forded the Black Creek, and headed toward the Helderberg escarpment, where many of them settled and built their farms at the foot of the "bright and clear mountain."

In the 19th century, Guilderland was rural America in microcosm. Agriculture replaced forest wilderness, and as turnpikes and railroads cut through the countryside, hamlets and crossroad communities developed. Town government and school districts were established, post offices opened inside general stores, and churches flourished. By the end of the century, Guilderland's 4,000 residents could read a weekly newspaper and attend an annual agricultural fair. A progressive town with small businesses, hotels, stores, and factories was in place. Yet life actually changed little in the 19th century. Children learned in the same one-room schoolhouses their parents had attended, travel was still by horse and buggy over dirt roads, families lighted their homes by kerosene, and there was a privy behind every house in town. Children born in the waning years of the 19th century, however, would grow old in a Guilderland far different from the one they experienced in their youth.

At the end of the 20th century, the western section of Guilderland remains mostly residential, with scattered farms and small businesses, though urban development is slowly changing the landscape. A State University of New York campus anchors the eastern end of the town adjacent to Albany, the state's capital city. That section of Guilderland has mushroomed into a growing commercial and residential suburb with a large shopping mall, several smaller shopping centers, business and apartment complexes, housing developments, and fast-food restaurants.

The Great Western Turnpike, which is referred to throughout this publication, is now more commonly referred to as Route 20. The old Schoharie Plank Road is now Route 146 from Route 20 to Altamont. We have attempted to begin the photo images at the eastern border of Guilderland and travel out the Western Turnpike to the town's other interesting communities, some of which have thrived while others have virtually disappeared.

One

McKownville and Westmere

McKownville derived its name from the John McKown family, who originated in Scotland, later moved to Londonderry, Ireland, and immigrated to America in the late 1740s. The first member, John McKown, leased the Five Mile Tavern near Indian Quad of the State University campus, built 200 years later. His son, William McKown, built a tavern in 1790 at a lonely crossroads (now Fuller Road and Western Avenue), anticipating the completion of the Great Western Turnpike in 1799. The turnpike became the main highway for travelers from the west to the Albany markets. The McKown family later donated land in Guilderland for the site of a church and school in the McKownville hamlet.

McKownville's proximity to the capital city of Albany destined it to become a hub of great business ventures. Although part of the hamlet retains its small community status, the boundaries of a metropolitan city and the New York State Northway and Thruway brought about its inevitable commercial and suburban destiny.

Westmere, on McKownville's western border, was a rural area with small cottages and isolated farmhouses dotting the landscape until returning World War II servicemen, looking for a "green spot" to raise their families, sought Guilderland's lush farmlands. One-family housing developments sprang up along the turnpike, renamed Route 20. Westmere, the hamlet connecting McKownville and Guilderland, is not noted in older history annals.

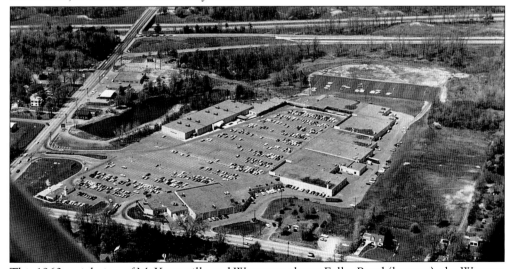

This 1960 aerial view of McKownville and Westmere shows Fuller Road (bottom), the Western Turnpike/Route 20 (upper-left), and Stuyvesant Plaza (bottom center), which opened in 1959. Also pictured is the New York State Northway (top).

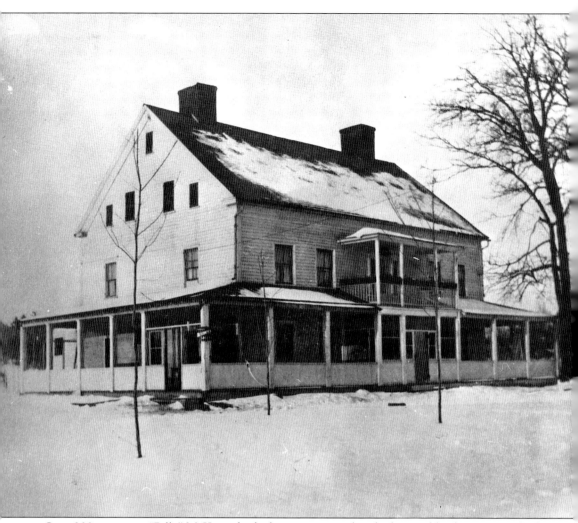

Over 200 years ago, "Billy" McKown built this tavern on a lonely dirt road leading west to feed hungry pioneer travelers. He cleared the land 5 miles west of the Hudson River, anticipating the construction of the Great Western Turnpike. McKown gave right-of-way to the Turnpike Company over a parcel of 600 acres. His tavern prospered, and the inn became a stopping place for New York State militia units, who camped on the tavern grounds on their way to Anti-Rent Wars in the Helderbergs (1839). McKown became the supervisor of Guilderland from 1813 to 1824. In 1884, William Witbeck bought the tavern, and it housed McKownville's post office until it was destroyed by fire in 1917. The King Shell Station then occupied the site. Today, fast-moving travelers stop at the same acre of land, at the busy intersection of Fuller Road and the Western Turnpike, to satisfy their hunger at a Burger King restaurant located on the historic site.

The McKownville Methodist Church was founded as a mission church for the Methodist Church in Hamilton, an early name for the village of Guilderland. The first structure of the McKownville Church was built in 1866 on land donated by John McKown, the son of William McKown. Rev. Edward Taylor was pastor. The original building, which still stands today, was erected on the Western Turnpike in 1898. At that time, Rev. Hamilton Allen supervised the building of the new church; it had a congregation of approximately 90 members.

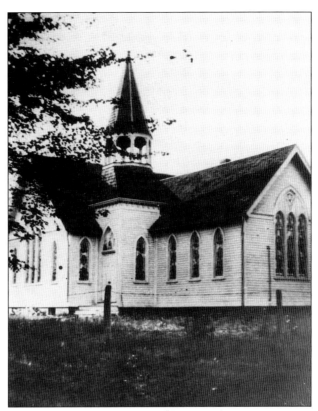

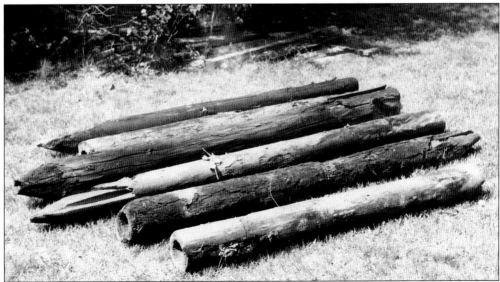

This system of hollow-log conduits, laid from the branch of the Krum Kill, served as McKownville's first water source in 1824. Sections of wooden pipes were 6 inches in diameter, and 6 feet long with a 2-inch bored hole. In order to fit together, one end of the pipe was pointed and the other was tapered. The water serviced the old McKown Hotel, the stock pens nearby, and several residences. The conduits were unearthed in 1969 near the McKownville Filtration Plant.

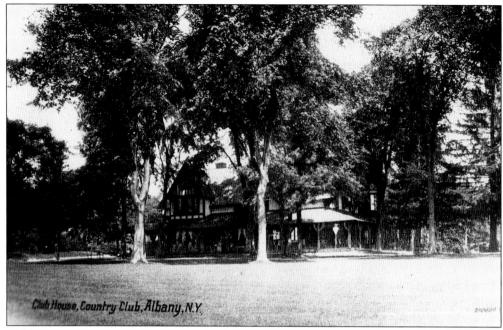

Club House, Country Club, Albany, N.Y.

The Albany Country Clubhouse, set back from Western Avenue at the Guilderland/Albany City Line, was built in 1896. The King's Highway roamed through this scrubland in the mid-1700s for travelers heading west from Albany through the Pine Bush. The first tavern on the old road was the "Five Mile Tavern," built near the present site of Indian Quad on the State University of New York campus. The old road was obliterated by the Albany Country Club golf course and the university buildings. The clubhouse burned in February 1963.

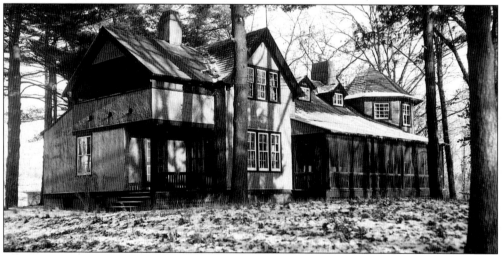

In a woodland setting at the end of Waverly Street in McKownville, this baronial hunting lodge once housed political secrets at meetings of the "Barnes Machine." It was built in 1905 by William Barnes, who was the powerful chairman of the Albany County Republican Committee and the grandson of prominent politician and journalist Thurlow Weed. The rustic house, finished with wide-board teak flooring and a two-story main hall with a massive fireplace, became the Chapel House for the State University of New York. It was destroyed by fire in the summer of 1985.

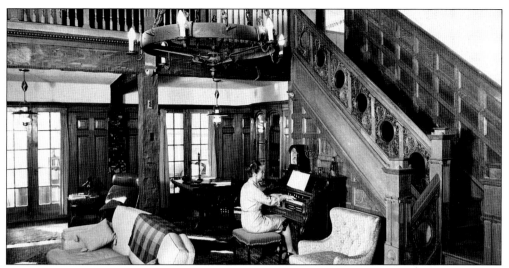

Albany attorney Thomas F. Wood built this early 1900s home, composed of bits and pieces of old Albany houses, as a wintering spot next door to the Barnes lodge. The living room was comprised of bits of the Brewery Inn. The oak cabinets and paneling came from the Myers and Whitney Houses, which once stood on Albany's Capitol Hill. Ceiling beams were from an ancient stable, and the chandelier was made from a wagon wheel and Civil War bayonets. Former University Dean of Students Mrs. Lois Gregg lived in the Wood House before it was demolished for university expansion.

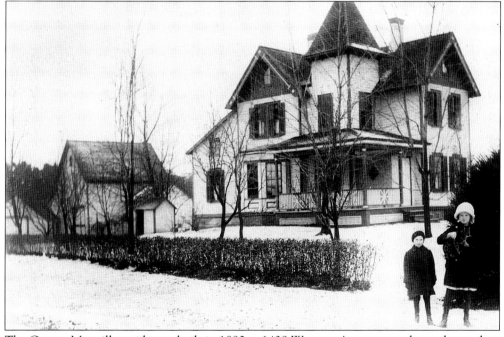

The George Manville residence, built in 1880 at 1438 Western Avenue, was located next door to the Tom Sawyer Motor Inn. Mrs. Manville was the organist at the McKownville Methodist Church from 1896 to 1951. The house was later occupied by the Crouse family. In 1980, it was converted into the Huckleberry Finn Pottery shop. The land is presently occupied by the Passonno Paint store.

The Tom Sawyer Motor Inn on Western Avenue brought classy new traveler accommodations and elegant dining to Guilderland. Built in 1950, it became a popular meeting place for many community and business groups in town. McKownville's first traffic light was installed at Fuller Road and Western Avenue a year after the inn opened. A swimming pool was added on the front lawn several years after this picture was taken. A Holiday Inn Express and two medical offices now occupy this site.

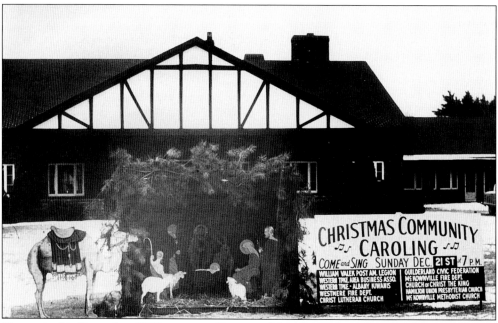

Shown in this December 1958 view is a Christmas Nativity scene in front of the Tom Sawyer Motor Inn. The scene was heralded by a community Christmas caroling that became a custom for many years. The event was sponsored by Western Turnpike Kiwanis, the Western Turnpike Rescue Squad, the Westmere and McKownville Fire Departments, the McKownville Fire Ladies' Auxiliary, the Westbrook Association, and the McKownville Methodist Church.

McKown's Grove was a favorite swimming spot in Guilderland for many years. It was opened in 1896 by William (Squire) McKown, grandson of the tavern-famous "Billy" McKown. The old swimming hole began at the dam of the water supply, causing the hamlet of McKownville to become a mecca for picnics, swimming outings, and clambakes. The Grove, situated on the land behind the Tom Sawyer Inn, was closed in 1980. A medical office building is presently located on the site.

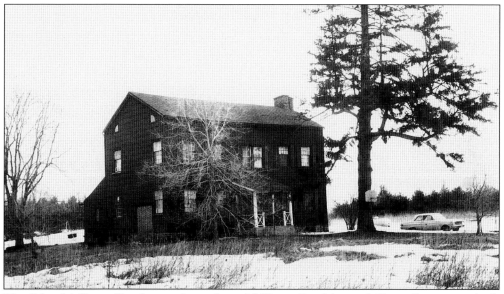

The John McKown Farmhouse, located on McKown Road beyond Short Street, was built c. 1815. The house and land, carved out of "Billy" McKown's land holdings, was most likely a wedding present to his son John and his son's bride, Catherine Hilton. The house had a fireplace in every room and a large kitchen fireplace in the basement, complete with a crane. It later became the residence of William and Margaret Knowles, before being demolished in 1970.

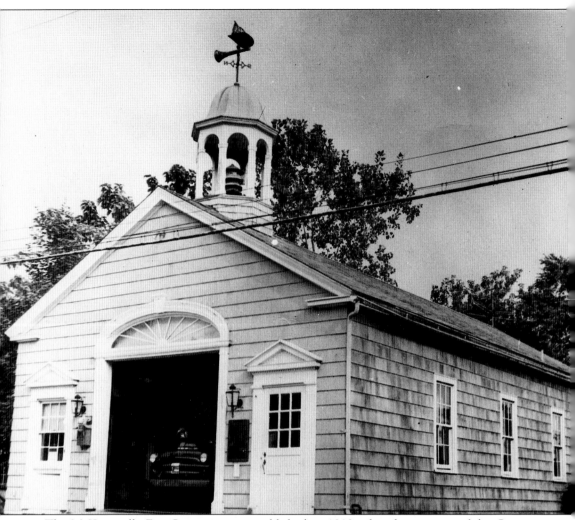

The McKownville Fire Company was established in 1918, after the opening of the Country Club Trolley Line. One early piece of fire equipment was a two-wheeled hose cart with a chemical tank housed in the carriage house behind the Witbeck (McKown) Hotel. The first alarm system was a locomotive tire hung outside the hotel that was hit with a sledge hammer in times of emergency. In 1933, on land offered by the Shell Oil Company, the Arcadia Street Firehouse was built for $10,850 and was dedicated on April 6, 1935. Today, the McKownville Fire Department has a three-bay firehouse on the Western Turnpike with three pumpers and a squad truck.

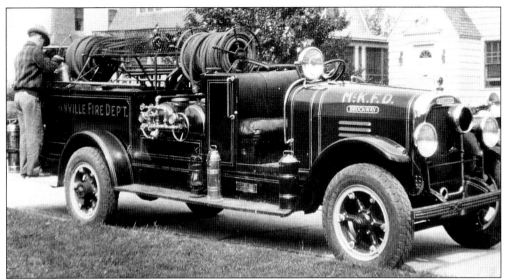

This Brockway fire truck was purchased by the McKownville Fire Department in 1931 for $1,825. It serviced the McKownville district until 1951, when it was retained as a second truck due to its small size and ability to get over narrow roads of the Pine Bush to fight brush fires. A new $20,000 Dodge fire truck was purchased in 1957, and the Brockway truck was sold to a New England amusement park for $150.

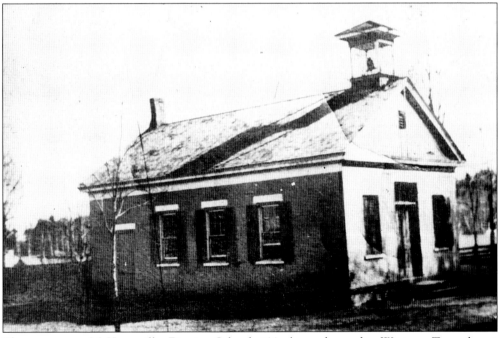

The one-room McKownville District School #11, located on the Western Turnpike at Schoolhouse Road c. 1877, had another room added at the turn of the century. Land for the school was deeded by the McKown family. The school was retired in 1954 when the Guilderland School District consolidated and the Westmere Elementary School opened. The John G. Myers Company opened a children's clothing store in the brick building, but it was destroyed by fire in the late 1950s. Albank is located on the premises today.

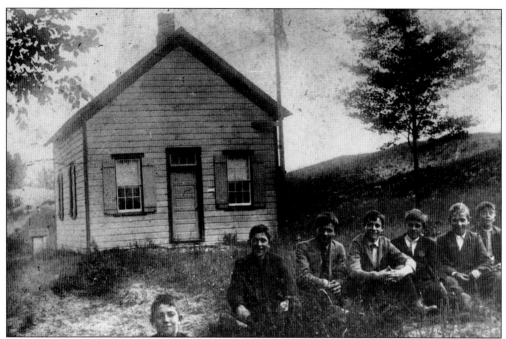

The McKownville Annex School #11-A was located on Johnston Road, opposite Veeder Road. It was built in 1887 and retired in 1953. The young Guilderland students pictured here are, from left to right, Joseph (John) Stahl, Harold Albright, Raymond Ableman, Charles Johnston, Arthur Manweiler, Floyd Johnston, Allen Gerald, and Charles Ableman. The date of this photo is unknown.

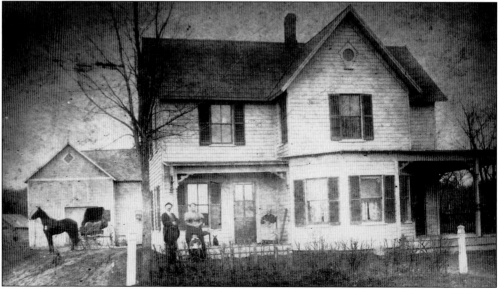

Unrecognizable as Western Avenue, this *c.* 1890s photo shows William and Hannah Knowles with their son William at their 1261 Western Avenue home built in 1884. Grandmother Knowles is seated on the front porch. William Knowles later resided in the John McKown Farmhouse on McKown Road. Note the horse and buggy on the dirt driveway (now Knowles Terrace).

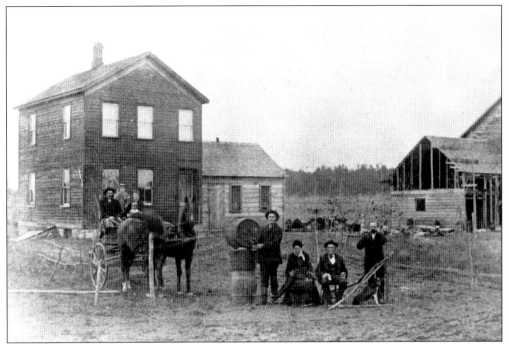

This image of the Gustave Ziehm House and barn on Schoolhouse Road was taken *c.* 1885. Ziehm and his wife, Marie, are in the wagon with their son Gus; seated in the yard are Ziehm's parents with neighbors standing by. The barn still stands, but it is now on the Woodlake Apartment grounds beside the tennis courts.

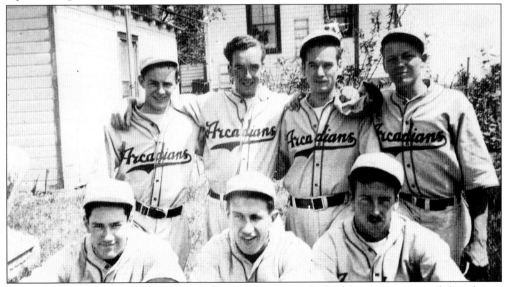

The McKownville "Arcadians" baseball team was named after the street most of the players lived on. The swampy and brush-filled playing field was located behind the Whitbeck Tavern. The team included Spencer Noaks, Ossie Gepfert, the three King brothers, Tom, Chet, and Jack, Ed Sickler, Bob Feldman, Stan Rice, Chuck Ebel, Fran Finegan, Clint Groves, Bill May, Fran Scanlon, Bill Thompson, Arn Volk, and others. The team disbanded when the Tom Sawyer Motor Inn was built on the Whitbeck Park land.

The electric trolley that serviced McKownville residents at the turn of the 20th century stopped at the Albany City line before it entered the hamlet. This transportation marvel was proposed to reach from Manning Boulevard in the city to the hamlet of Fullers, 7 miles out on the Western Turnpike in Guilderland. The proposal died, and a single track was laid from Manning Boulevard to the Krum Kill at Guilderland's border, where Sutter's Mill presently stands opposite the entrance of the State University at Albany.

The Christ Lutheran Church, located on the Western Turnpike at Highland Drive, was built in 1957. The roots of the church in the eastern end of Guilderland go back to 1928, when two Lutheran Seminary students canvassed the 4,000 residents of the town of Guilderland. First services were held in an apartment on the Western Turnpike in 1931. After several moves, the Church bought land under the auspices of the Reverend Arthur Gerhardt, whose ministry there spanned from 1944 to 1979. Reverend Gerhardt remains active even in retirement, serving as vacancy minister at several churches.

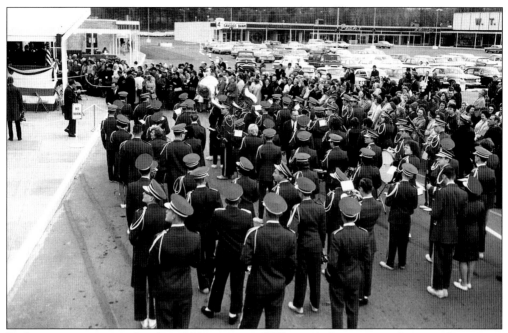

Dedication ceremonies for the 1964 opening of Whitney's Department Store at Stuyvesant Plaza drew a large gathering of Guilderland residents. Music was provided by the Guilderland High School Band. Officials in attendance included Town Supervisor Gordon Robinson and Lewis Swyer, the building contractor. Built on land that once housed the cattle of drovers staying at "Billy" McKown's tavern, the shopping center heralded a new era of business in the Guilderland township.

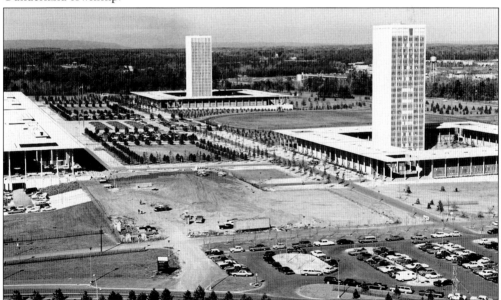

The changing face of McKownville in the town of Guilderland is depicted by two of the four SUNY student resident towers rising on the community landscape in the early 1960s. Today, additional high rise buildings join the changing scene to alter the view of the Helderberg Mountains on the horizon.

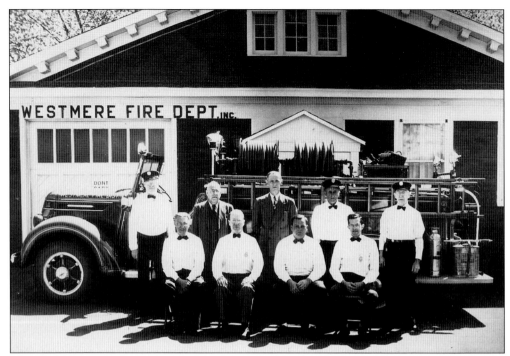

The Westmere Fire Department, organized in 1935, built a one-bay firehouse at 1690 Western Avenue. This photo shows a 1937 fire truck. From left to right are as follows: (seated) J. Fullenwilder, J. Clas, Ed Keller, and Howard Beebe; (standing) G. Trap, Ed Gladding, E. Hennessey, H. Sager, and C. Goodrich. The fire district population grew from 400 in 1937 to 10,000 in 1998. The department presently protects five shopping malls. Its facilities include a new, five-bay building that houses three pumpers, an aerial truck, and a rescue vehicle.

In the 1940s, the Leopold Stahl residence at 1745 Western Avenue included a 5-acre pig farm. Mr. Stahl was born in 1871 and operated this farm and a garden farm on Veeder Road off Johnston Road. The Pine Bush Little League played baseball games on his property. In 1955, a parcel of the Stahl land was acquired by the Westmere Fire Department for the building of a new firehouse. The Monroe Muffler Company now occupies part of the land.

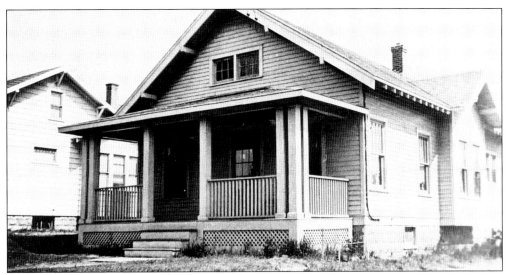

This is a typical 1935 bungalow along the Great Western Turnpike (now Route 20) in Westmere. Most of these cottage-type homes sprang up in what had been farmland in the post-World War I era. The name "Westmere" came into being in the 1940s with the post-World War II surge in building. There is little earlier history written about this section of the town of Guilderland.

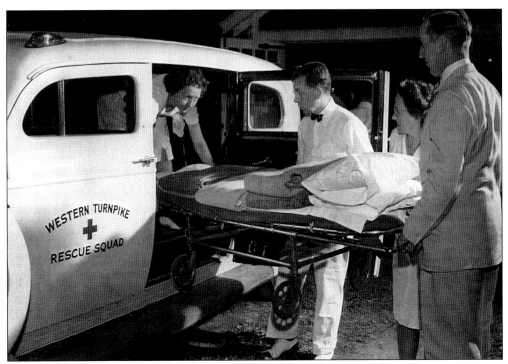

The Western Turnpike Rescue Squad was established in 1939 and was located on the Western Turnpike and York Road. In 1952, the squad had a budget of $2,856 and a total of 108 calls for the year. In 1997, the squad answered approximately 3,000 calls and had a budget of $150,000. The volunteer squad now has two buildings and three ambulances. This 1946 picture shows rescue squad workers with a 1939 Dodge ambulance.

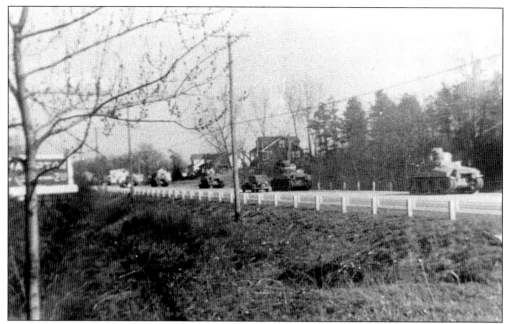

In this 1945 scene of the Western Turnpike, U.S. Army tanks make their way from the Voorheesville Army Depot. To the left of the photo (the north side of the road), near the sign, is the present-day Frame and Art Shop. The wooded area of the south side of the turnpike is now Cosimo's Plaza.

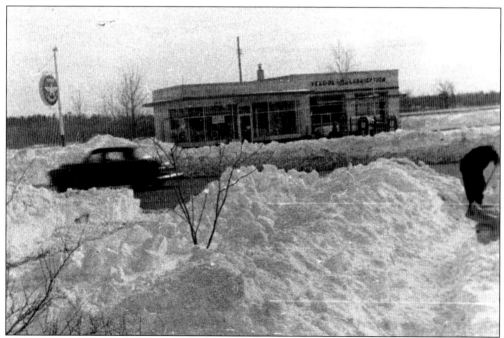

This is a winter scene at 1814 Western Turnpike, on the south side, where the Tydol Station was built in 1946. It was one of the first large corporation gas stations to be built in the area. Figliomeni's Restaurant is presently located there. Snowblowers were not a convenience as they are today. There were several 1935 bungalow-type houses in the area of the shoveler.

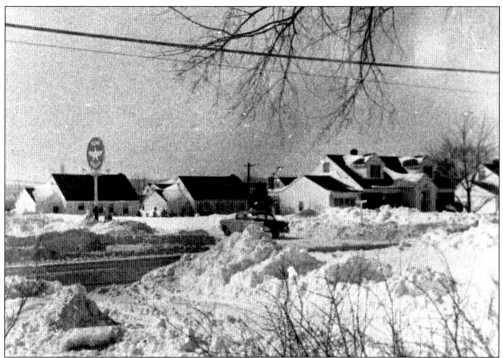

It is 12 years later (1958) in this snowy winter scene on the turnpike. A new town road called Kraus Terrace has been built next to the Tydol Station. In the era of returning World War II servicemen, Westmere had the fastest population growth in town. The population grew from 7,284 in 1950 to 14, 989 in 1957.

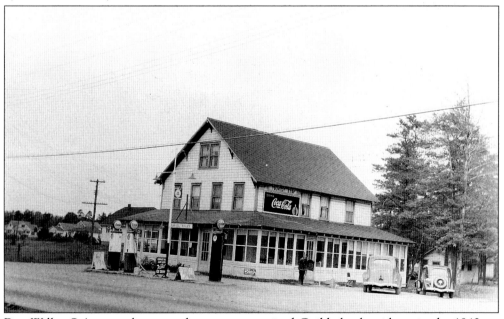

Dan Willey Sr.'s general store and gas pumps serviced Guilderland residents in the 1940s at the northeast corner of the Western Turnpike and Gipp Road. It was one of two grocery stores located between Fuller Road and Route 155.

One-room, wooden tourist cabins behind Dan Willey's grocery store housed travelers coming from the east or the west on the turnpike in the early 1900s. There were many of these simple types of accommodations along the westbound road. The "country" atmosphere even brought families from Albany for an overnight adventure in this rural region.

The Caroline Railroad, operated by conductor and engineer L.P. McGrath, delighted Guilderland youngsters with train rides on summer evenings and weekends. The 10¢ after-dinner rides, which took place on Willey Street near Gipp Road and the turnpike, came to a halt in 1969. According to the engineer, "revenue did not meet expenditures."

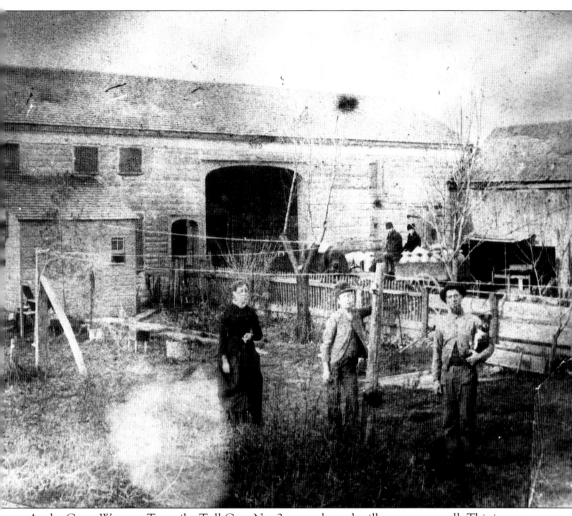

At the Great Western Turnpike Toll Gate No. 2, a westbound milk cart pays a toll. This is one of the very early images of Westmere, which was then a sparsely populated area. The tollkeeper's wife, Mrs. Williams, stands in the foreground. After the Revolutionary War, emigration to the west increased greatly. In 1796, three hundred sleighs or wagons passed through Albany and Guilderland on a westward journey, necessitating the need for better roads. In 1799, the Turnpike Corporation began charging tolls: 5¢ for each score of sheep or hogs, 12¢ for a horse with rider, and 25¢ for a wagon. The toll gate was located where the Turnpike Drive-In once stood, before the present-day Highwood Village complex was built. The toll gate building was moved in 1907.

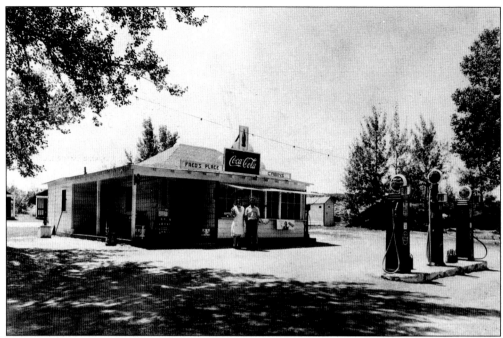

"Fred's Place," located on the two-lane Western Turnpike near State Farm Road, consisted of a gas station, snack bar, and tourist cabins. Owned by Emily and Fred Rudesheim from 1939 to 1970, the family-run business was on the site of the current Dunkin' Donuts at Star Plaza. Today, the heavily traveled intersection, with its multi-synchronized traffic light, is a far cry from when the small country business held forth on the turnpike.

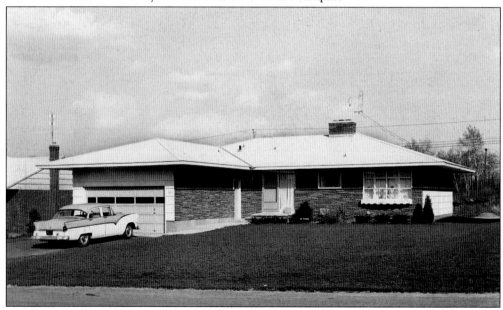

A typical 1950s ranch-style house with a typical 1950s car parked in the driveway shows the new one-floor housing construction that replaced the cottage- and bungalow-style houses of previous years in Guilderland. Tract houses of this sort, if kept in original condition, will soon be considered "historic" and possibly eligible for the National Historic Register.

Two

GUILDERLAND HAMLET

The hamlet of Guilderland was formed a number of years before the town of Guilderland was incorporated in 1803. Dutchman Leonard DeNeufville began a small glass factory in the tiny area 7 miles west of Albany, known as Dowesburgh, on the Great Western Turnpike. In 1797, the land around the glass factory was laid out in streets. The village was renamed Hamilton, after the U.S. secretary of treasury, and 54 community houses were built for the factory workers. In 1799, the Great Western Turnpike was built through Hamilton and many taverns and businesses sprang up. In 1815, the first official post office was established, and the village was renamed Guilderland. Prominent names like Van Rensselaer, Batterman, Schoolcraft, Veeder, and Sloan appeared on the tax rolls. A new foundry, a church, a school, and several taverns and inns were added, and the small village began to flourish. Today, the hamlet of Guilderland boasts a new library, a large elementary school, several historic houses, an addiction recovery center, a nursing home, and an apartment complex, and heralds the coming of a YMCA.

This panoramic view from the elevated height of Prospect Hill Cemetery scans the ever-changing face of Guilderland. The Jackson Tavern (pictured) was built in the early 1800s by Judge James A. McKown, grandson of "Billy" McKown. The building was dismantled in August 1996 and was moved near Cooperstown, where it will be re-assembled. The photo predates its present backdrop, the Regency Apartment Complex.

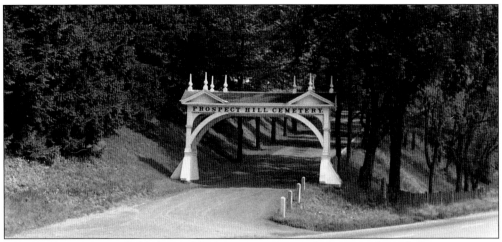

This is a 1950s view of the beautiful Victorian gateway that once adorned the entrance to Prospect Hill Cemetery on the Western Turnpike. The cemetery was chartered in 1854. Located high on the hill overlooking the town, it is the highest point on the turnpike, a fitting site for the historic heroes and heroines of Guilderland's past, and the view from it is euphoric. From this lofty burial ground, one can watch the changing face of Guilderland.

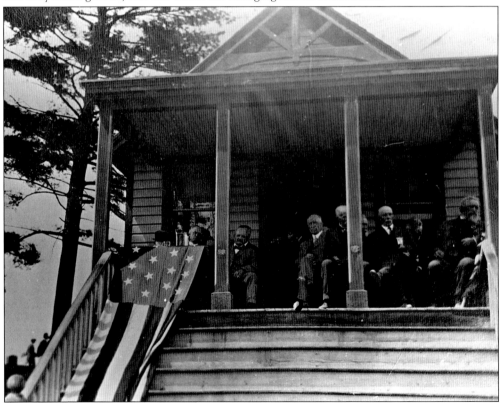

On the porch of the Victorian cottage in Prospect Hill Cemetery, Grand Army of the Republic Civil War veterans await dedication ceremonies in their honor on Memorial Day in 1910. A red-stone obelisk monument at the top of the entrance road in the cemetery also honors Civil War veterans.

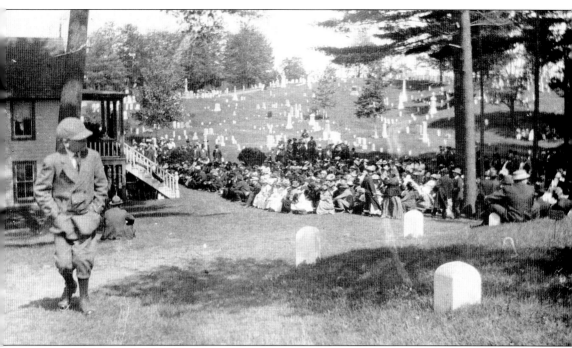

In the late 1800s and early 1900s, Prospect Hill was a gathering place for the living and the dead. It was customary for families to pack a picnic lunch and go to the burial grounds for an outing. From the porch of the small Victorian caretaker's cottage, dignitaries would assemble to give a speech and the town band would play. On Memorial Day in 1890, members of the Barkley Post, Grand Army of the Republic and townsfolk gathered to hear Guilderland poet Magdalene La Grange read her tribute to the fallen men of the Civil War. "We come today remembering the loved, the tried, the true, To deck the place where lie in peace, the boys who wore the blue." The Victorian cottage was demolished in the spring of 1998.

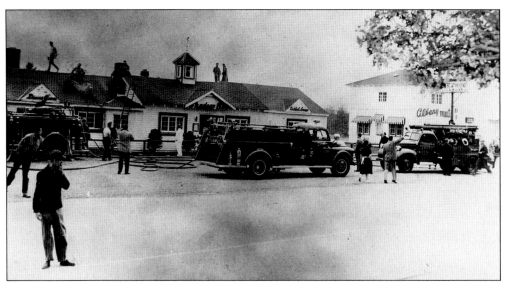

The McKownville, Westmere, Guilderland, and Fort Hunter Fire Departments answered a call on September 19, 1954, at the Shadow Box, a popular seafood restaurant and nightspot located across the Western Turnpike from Prospect Hill Cemetery. A second fire destroyed the building in 1976.

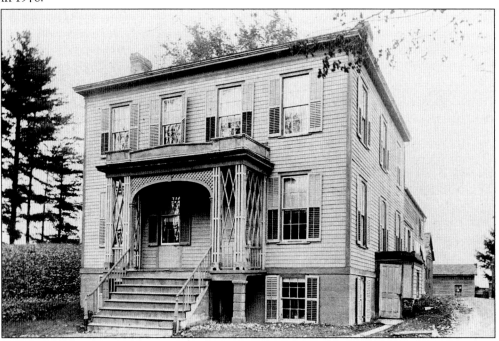

The impressive Rose Hill mansion has seen many changes on the Western Turnpike since it was built in 1842 by John P. Veeder. He was appointed during Lincoln's administration to investigate the U.S. Navy's scandals of the 1860s. Dr. Abraham DeGraff took the building's title from 1880 until the turn of the century, when it was let out to tenants. Schoharie County Doctor Miller Lee bought Rose Hill in 1945. The present owners, Drs. Lynn and Joseph Golonka, have kept the Federal-style historic house in mint condition. This photo was taken c. 1890.

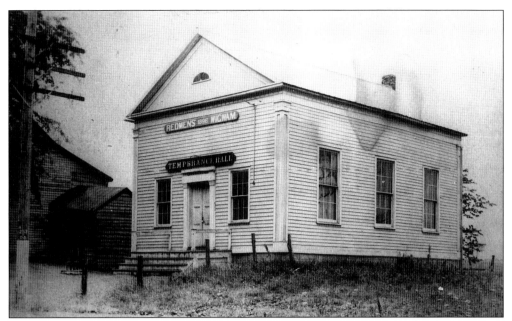

Once a pivotal place in the community, Red Men's Wigwam stood on the south side of Western Turnpike, east of Willow Street, from 1831 until it burned in 1967. A fraternity founded in 1765, the Red Men, earlier known as the Sons of Liberty, worked underground to help establish freedom and liberty in the colonies. This building was originally a Baptist church built on land donated by hotel owner Henry Sloan. It later housed a Catholic church, the Red Men, a temperance group, a polling place, and a work area for Red Cross women during World War II.

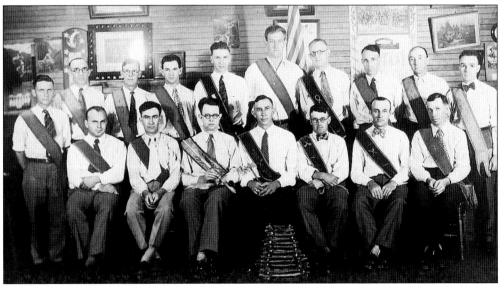

Guilderland "Red Men" of the Iosco Tribe #341 pose for a 1929 picture inside the Red Men's Wigwam, dressed in their ceremonial sashes. After the Revolutionary War, the Order of Red Men became a community-oriented, non-profit organization chartered by Congress. The national organization still supports flag recognition programs and observes a "Red Men's Day" at Arlington National Cemetery to honor soldiers fallen in battle.

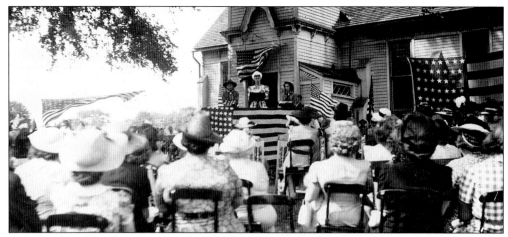

A dedication of the flag service on the Fourth of July in 1942 brought residents of the Guilderland hamlet to watch from the lawn of the Hamilton Union Presbyterian Church, located beside the Schoolcraft House. The church, established in 1812, was an octagonal structure that stood above a ravine and a stream east of the Batterman and Schoolcraft taverns. The building also became a superior preparatory academy for boys.

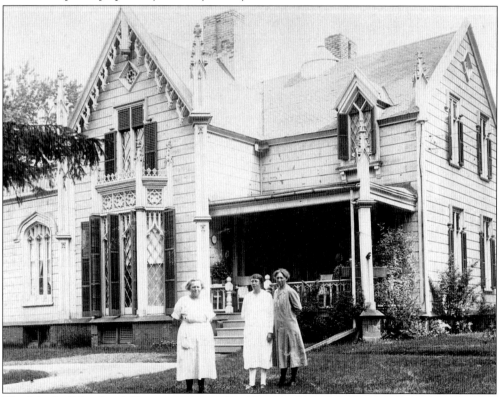

The John L. Schoolcraft House is a unique local landmark on the Western Turnpike. The early Gothic mansion was built in the 1840s by Congressman Schoolcraft, a wealthy banker and wholesale merchant. The house was purchased by Guilderland Historical Society and the Town of Guilderland in 1994 to be restored for use as a community cultural center. Pictured are the turn-of-the century residents of the house, sisters Alice, Edna, and Nellie Magill.

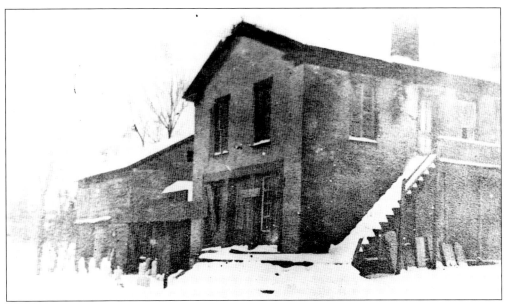

The two-story brick building at the corner of Schoolcraft Street and 2301 Western Turnpike was once the carriage and harness repair shop of Christopher Batterman, Guilderland supervisor from 1833 to 1839. Batterman created Mill Pond, located west of Hamilton Street, for his gristmill. In 1951, the building became the first firehouse for the hamlet, housing a 1937 Mack Jr. truck. The restored building is now occupied by InfoEd International Systems and Support Services.

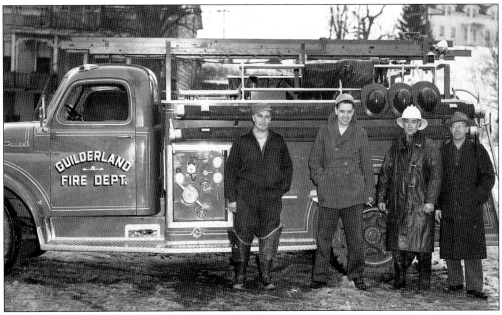

Four volunteer members of the Guilderland Fire Department pose in front of their 1951 Engine 25 Dodge pumper in this c. 1952 view. From left to right are Ross Mesick, Ken Cunningham, Tom Van Wagenen Sr., and Earl Kisby. The photo was taken on Foundry Road in front of the white Pruskowski House on the hill. A new, three-bay firehouse was built on the turnpike in 1994, housing four new pieces of fire apparatus. The old 1951 pumper is still used for parades.

This peaceful-looking country road is today a busy thoroughfare. Driving east from this point on the Western Turnpike toward Schoolcraft Street in this decade, you would have just passed a traffic light and, perhaps, read the informational sign in front of the new Guilderland Firehouse on your left. The brick building was Batterman's Carriage Shop and the original firehouse in the Guilderland hamlet.

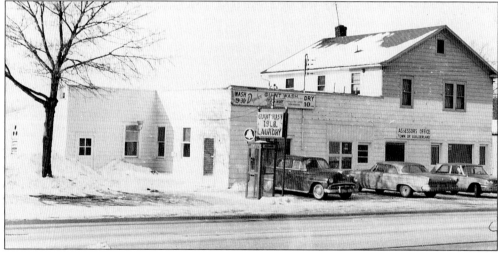

After a short life of 27 years, this building on the Western Turnpike across from Willow Street burned to the ground. Beginning in 1942, it housed Wells' gas station, a repair shop, restaurant, residence, laundromat, and a bus shelter. From 1950 to 1956, the Town of Guilderland held all of its meetings in rooms on the east end of the structure. Supervisor John J. Welsh moved town offices to the old schoolhouse on Willow Street in 1956. The Guilderland Free Library was also housed here from 1959 to 1961.

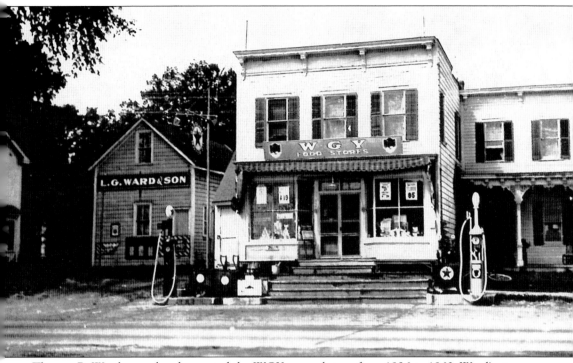

Thomas B. Ward owned and operated the WGY general store from 1926 to 1960. Ward's store, located on the Western Turnpike between Schoolcraft and Willow Streets, was a favorite gathering place for the folks in the small hamlet and was where they paid their town taxes in the 1930s. Ward also sold gasoline at his store and delivered groceries through the Pine Brush by horse and carriage. He served as postmaster from 1927 to 1965. Note the two-lane road very close to the entrance steps. A second-hand clothing store, Unique Boutique, presently occupies the building.

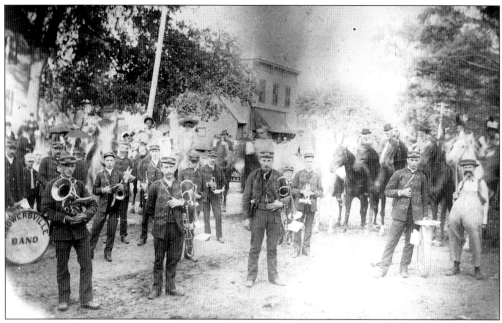

In this *c.* 1890 view, the Knowersville (Altamont) Band parades past the Western Turnpike Plank Road in front of a store that later became Ward's Market and Post Office. The spirited band, led by a marshall on horseback, furnished music for picnics and memorial services. The band had been playing for a Memorial Day service at Prospect Hill Cemetery. Note the dirt road with one strip planked.

This is a turn-of-the-century winter scene looking from Foundry Road across the Western Turnpike to Willow Street. Note the horse-and-sleigh transportation; the new, horseless carriages were made immobile by the weather. The building pictured is now Capital Costumes, located at 2319 Western Turnpike.

Men of Guilderland's 1899 Iosco baseball team are seated on the store steps at the corner of Foundry Road and the Western Turnpike. Iosco was the name used by Henry Rowe Schoolcraft, writer of Native-American legends and poems that included memories of his hometown. He was born in a house that still stands on Willow Street. Pictured from left to right are as follows: (first row) William Mynderse and DeWitt Main; (middle row) James Clark, Lloyd Coss, and Albert Talmadge; (back row) Walter Magill, Thomas Holmes, Fred Degraff, and Jesse Wood.

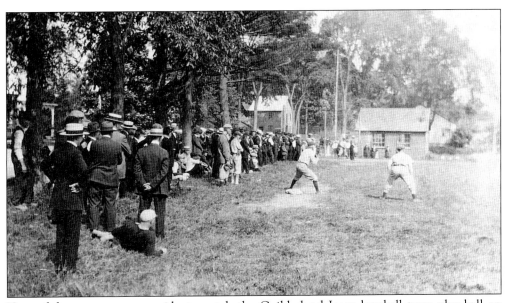

Turn-of-the-century town residents watch the Guilderland Iosco baseball team play ball on Iosco field, on the south side of the Western Turnpike. Perhaps it was a Sunday after church. Note the straw hats and suits of the male spectators.

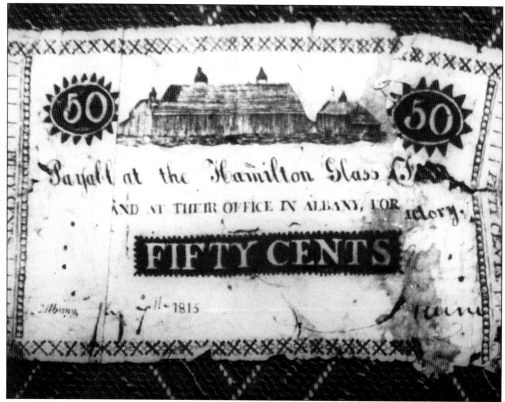

This 50¢ script from the Hamilton Glass Works of Foundry Road in Guilderland hamlet is dated 1815. In a wilderness about 7 miles west of Albany, with natural resources of sand, potash, wood, and waterpower, Leonard DeNeufville established the Dowesburgh Glass Works in 1785. By 1813, the small factory was outputting 500,000 feet of window glass per year. Competition from English manufacturers cut the life of the Guilderland factory short after 30 years.

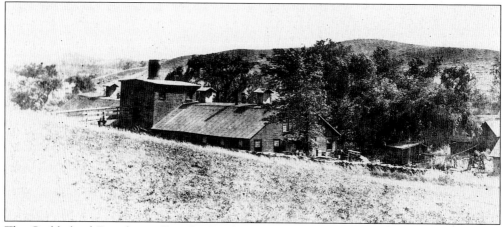

The Guilderland Foundry on Foundry Road was previously a hat factory turned into an iron-casting business by owners George Chapman and Jay Newberry in the 1860s. The foundry, once the site of the old Hamilton Glass works, produced brackets for the Castleton piano factory, manhole covers, and sash weights. It is believed that the decorative iron finials adorning the Schoolcraft House may have been made at the foundry.

In this view, Dr. Abram DeGraff stands in front of his medical office on Foundry Road. The doctor and his wife, Mary Francis Veeder, lived at Rose Hill across the turnpike. She was the daughter of the original owner of Rose Hill.

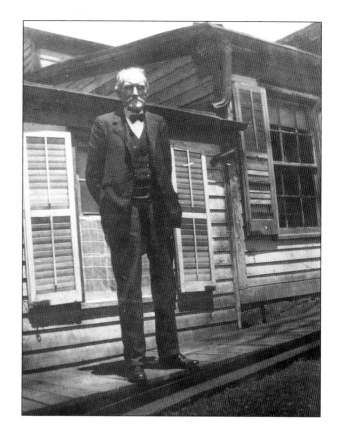

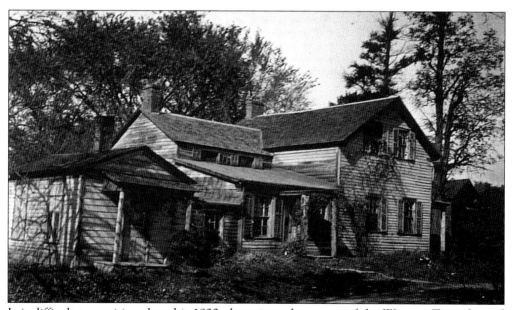

It is difficult to envision that this 1922 photo is at the corner of the Western Turnpike and Foundry Road. The little building on the left was the office of Dr. Abram DeGraff. The old house still stands today.

Christopher Batterman built and operated a large, brick hotel on the south side of the Western Turnpike, west of the Schoolcraft House. When Henry Sloan married Batterman's daughter, he took over the hotel and named it Sloan's. Note the single-lane road that was the beginning of the turnpike. History notes that Theodore "Teddy" Roosevelt stayed here on his way west. The hotel burned in 1900. The house in the foreground was the Rheinhardt residence.

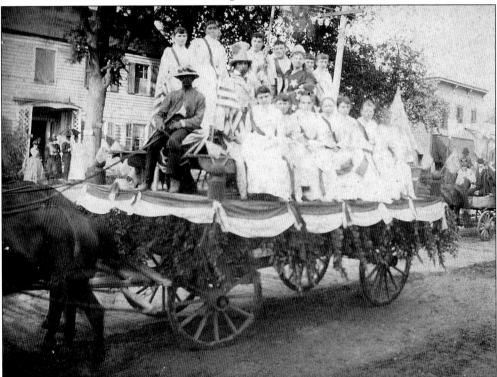

A Fourth of July celebration, c. 1890, shows schoolchildren on a parade wagon with Uncle Sam and Miss Liberty. The photograph was taken at the Willow Street intersection. This indicates the kind of community events in which the whole hamlet participated. Note two familiar buildings in the background and the wooden plank turnpike.

This is a c. 1900 view looking north on Willow Street, in front of District #4 Schoolhouse. It became the town hall in 1956 and is presently the New York State Troopers' barracks in Guilderland hamlet. The unpaved road and lines of trees are evidence of the rural nature of the village.

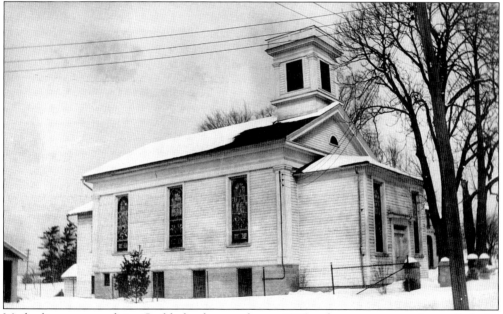

Methodism appeared in Guilderland as early as 1845, when a congregation called the Guilderland Methodist Episcopal Church was organized near the site of the glass factory. The church was built in 1852 on Willow Street. After 90 years, and with a diminishing congregation, some members merged with the Hamilton Union Presbyterian Church, while others joined the McKownville Methodist congregation in eastern Guilderland. The building was demolished in 1942.

Employees of the hat factory on Foundry Road pose in this *c.* 1886 view wearing the results of their labor. George Chapman sits with Arnold on his lap, while Jay Newberry holds George. They were co-owners of the business. Will Kelly is sitting on the wagon.

The Case Homestead, built in 1796, was a famous Guilderland tavern and inn. Much of the window glass was from the Glass Works one-quarter mile east on the Western Turnpike. This historic home burned in 1950, after eight generations of the Russell C. Case family had lived there.

One of Guilderland's lovely old houses is situated on a hillock rising above the Western Turnpike at Hamilton Street. Floyd and Stella Bradt bought the house from Marjory Siver in 1924. It was owned by Helen and William Borden in the 1950s. The present owners have restored a grand look with new, white siding, blue shutters, and blue wicker porch furniture.

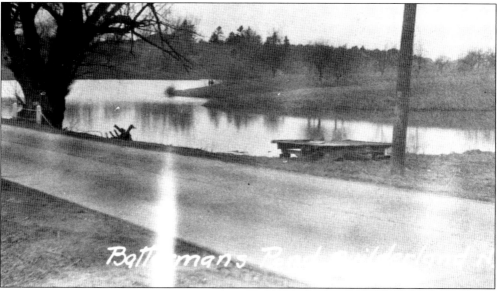

Wild ducks nest among the cattails and purple loosestrife in Mill Pond next to the Borden House on the turnpike. Older residents recall skating on the pond in the 1950s or watching as men chopped ice squares to sell in town. The pond was created by Christopher Batterman, who dammed up the land in 1841 for power to operate his gristmill. He sold the pond and 108 acres of land in 1853 to John L. Schoolcraft, who deeded it over to Henry Spawn in 1857. The town took possession of the land in the early 1900s. Mill Pond, one of Guilderland's prettiest assets, is also known as Glass House Pond and Batterman's Pond.

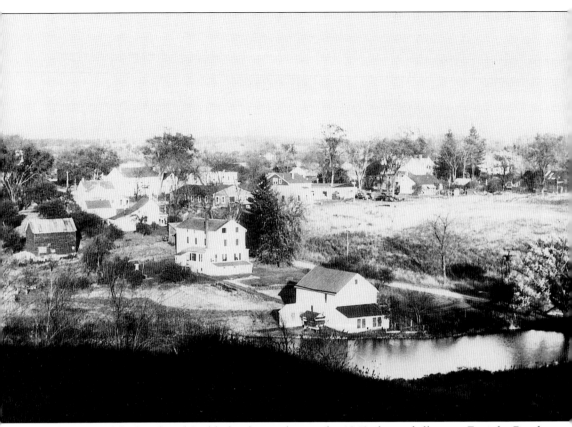

This view of the hamlet of Guilderland was taken in the 1940s from a hilltop on Foundry Road, looking north toward the Western Turnpike. It is a typical rural scene of past years. Foundry Road is visible in the foreground. The pond is made up of run-off waters from the Hungerskill. The Schoolcraft House can be seen in the background.

Three

THE GREAT WESTERN TURNPIKE

After the Great Western Turnpike was cut through the unsettled western part of Guilderland, taverns appeared and were soon followed by small clusters of farms and homes along the way.

The hamlets of Dunnsville and Fullers each began with an early tavern as the nucleus. Fullers became larger and more prosperous when the railroad came through and located a West Shore depot there. By the end of the 19th century, both Dunnsville and Fullers had their own post office, one-room school, blacksmith, general store, and other businesses. At that time, these hamlets had twice the population of the McKownville and Westmere areas.

Other locations along the Western Turnpike developed around intersections and became designated "corners." The corner around where the Schoharie Plank Road (later Route 146) turned south from the turnpike became Hartmans Corners, while to the west, McCormacks Corners was named after a store and early gas station at the intersection of Carman Road and the Western Turnpike. Today, the town hall's address is McCormacks Corners. Continuing west past Fullers was Sharps Corners at the intersection of the road to Schenectady (now Route 158) and the Western Turnpike.

These names show up on modern maps, but the people who inspired them and the sense of identity these areas once had are gone.

The intersection formed where the Schoharie Plank Road branched off from the Western Turnpike was designated Hartmans Corners, after the family who lived in this 1849 brick house. The Hartman house was razed in the 1960s to make way for a Texaco station, which in turn was demolished for Stewart's Shop at the corner of Routes 146 and 20.

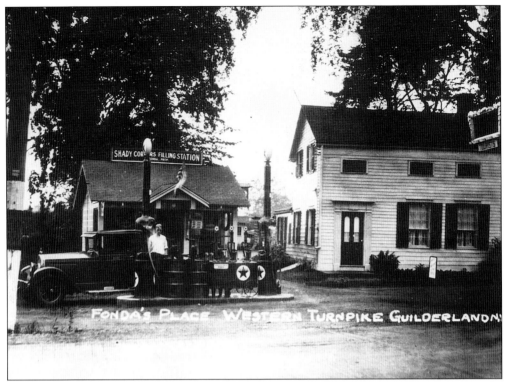

The first roadside stand along this section of the Western Turnpike was opened in 1920 by Harold Fonda. Selling hot dogs, ice cream, smokes, and soda proved so profitable that by 1925, he added one of the first gas stations on the turnpike. From the mid-1960s until 1997, Polito's Tavern operated in the same location on the corner of Routes 20 and 146.

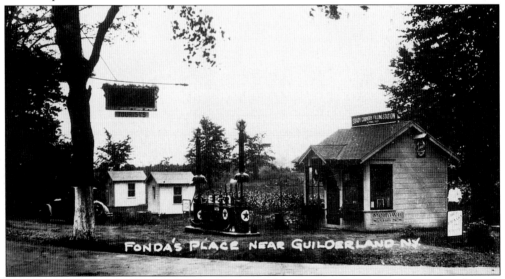

Fonda was an entrepreneur who took advantage of the increased auto traffic passing through Guilderland in 1926 to add a "cabin camp" to the roadside stand and a gas station he already operated. The number of cabins increased, and he eventually added a motel. Fonda remained in business until 1959. During those years, the intersection was often called Fonda's Corners.

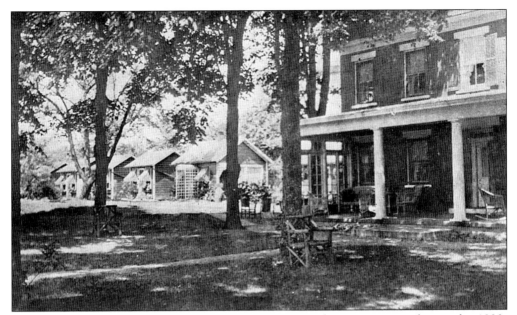

The large, old brick house opposite the Hartman House became a tourist home, the 1920s version of a bed and breakfast. Cabins were added in the side yard, as shown in this 1934 postcard, when Mr. and Mrs. J.J. Thearle were the proprietors. Later, a modern motel replaced the cabins. The house and motel unit still stand opposite Stewart's on Route 20.

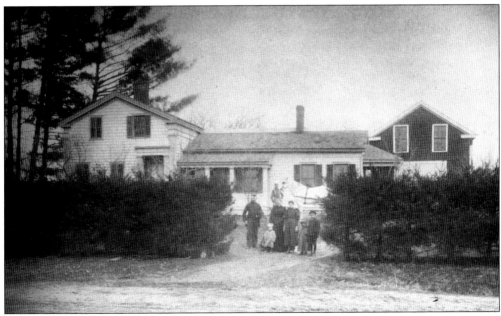

Evert Bancker, the third mayor of Albany, established a farm and country house near the Normanskill, regularly traveling by canoe to get there. The photo shows the house as it was c. 1895. Some time after this, the house burned and was replaced by the present one. However, the dark building at right survived and remains today. Its location is on Route 146, one-half mile south of Hartmans Corners.

Unusually heavy traffic was crossing the Normanskill Bridge when this photo was shot in 1926. The Evert Bancker Farm was nearby, and over the years, local people corrupted the name to "Bunker" for both the bridge and for the long hill Route 146 climbed on its way to Guilderland Center. Occasional floods on the Normanskill washed out successive bridges, including a covered bridge and an iron bridge, once resulting in a fatal accident.

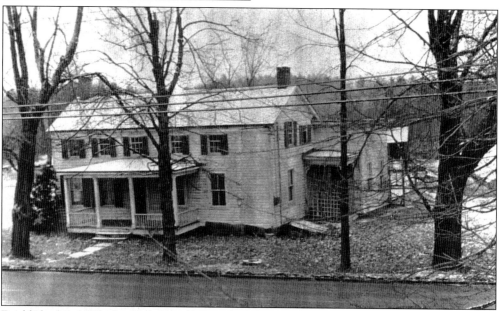

Established in 1876, the Gade Family Farm had the distinction of receiving one of New York's Century Farm awards, for having been worked by several generations of the Gade family for over 100 years. The original part of the farmhouse was constructed in the early 1800s. Seen in this c. 1950 photo, the house was dismantled for restoration on another site in 1984. Customers of Gade's Farmstand park on the site of the farmhouse, which stood along the Western Turnpike.

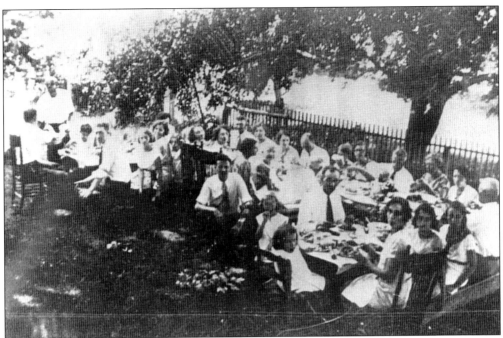

Summer picnics brought together family and friends, providing a welcome break in the usual routine. Here, members of the Gade family enjoy a clam bake in August 1932. With Peter Gade, founder of the family, raising 11 children on his farm, there was no shortage of relatives to join in on the fun.

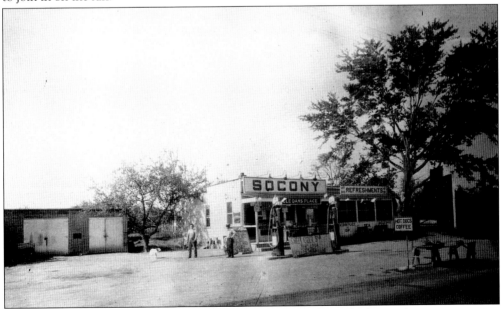

The road may have remained the Western Turnpike to local people, but to the ever-increasing number of auto travelers in the 1920s, the highway was called U.S. Route 20. Uncle Dan's Place, near McCormacks Corners, was one of any number of roadside businesses that sprang up to serve the traveling public. Uncle Dan could fill your tank with gas for 19¢ per gallon and fill your stomach with the "best coffee and sandwiches on the road."

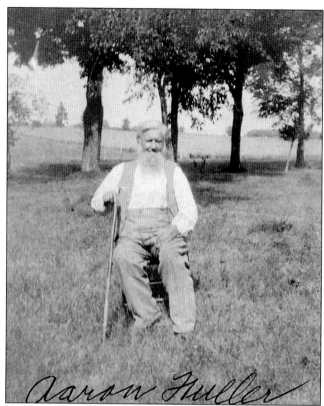

Aaron Fuller, one of Guilderland's most prominent citizens, sat for this photograph in 1900. He was an elderly man able to reflect on a productive life as a farmer, businessman, and politician. Because of his foresight in convincing the West Shore Railroad to build a station there, the hamlet of Fullers, west of McCormacks Corners on the Western Turnpike, grew prosperous. Fuller developed a thriving hay and produce business and was the only Democrat elected to the position of town supervisor for over a century.

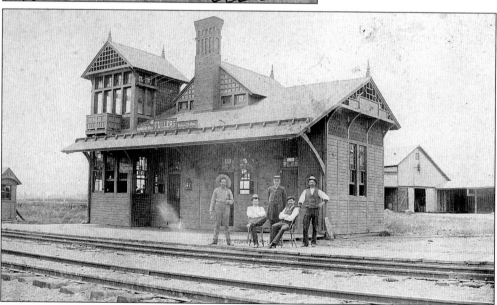

The West Shore Railroad's depot at Fullers was built in 1882 on Fuller Station Road, southwest of the Western Turnpike. Rail traffic was heavy enough through this small hamlet for incoming and outgoing mail twice daily. Students commuted for $7.50 monthly to Ravena High School at their own expense. Removal of the station became necessary in 1927, when the tracks were built above the level of the Western Turnpike.

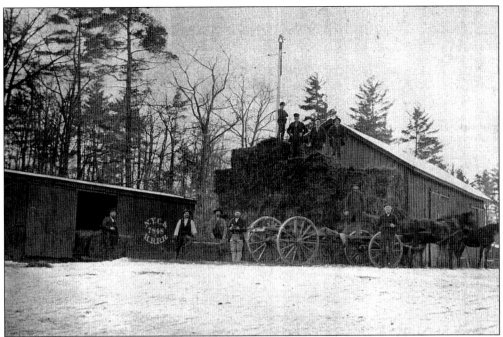

Behind Fullers Station was a huge hay barn. At Fullers, Aaron Fuller and the firm of Tygert and Martin each had a "hay press," a business that purchased hay from local farmers, then compacted the hay into bales so the maximum amount could be shipped out in boxcars to meet the huge urban demand in the horse-and-buggy era. The process of pressing and loading hay provided seasonal work for many men.

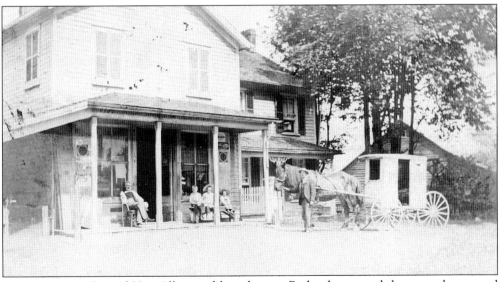

For many years, Samuel Van Allen, and later his son Richard, operated the general store and post office at Fullers. The store, shown here on a 1907 postcard, was located southwest of the Western Turnpike on Fuller Station Road. The post office was discontinued in 1918, and when the store closed, the building was converted into a home that remains standing today.

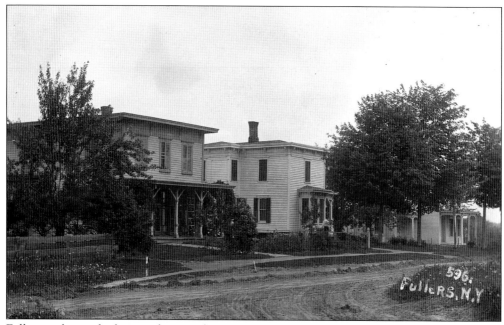

Fullers no longer looks as it does on this postcard stamped 1914, a time when the hamlet still had a store, post office, and school. The houses remain, but Route 20 was lowered in 1927 from the level it had been as the Western Turnpike At that time, the West Shore "flyover" was created to do away with a dangerous grade crossing, resulting in a very high retaining wall separating these houses from the road.

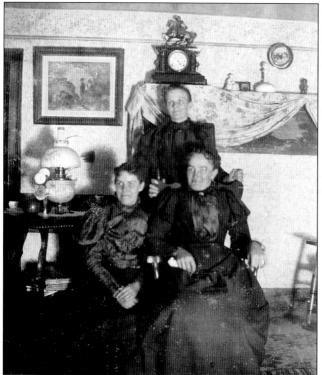

Major John Fuller, and later Aaron Fuller, presided over a tavern situated on the Western Turnpike at the northwest corner of Fuller Station Road. Later in the 1800s, it became a private home where, a century ago, Emma Van Allen, Sate Coss, and Ella Blessing sat for their portrait in the parlor. Note the Victorian knickknacks, fancy kerosene lamp, and draped mantle added to the Federal-period house to make it look more "modern."

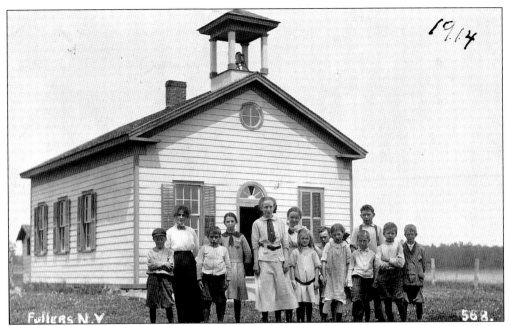

Among the students who lined up with their teacher in 1914 near the Fullers District #13 School on the Western Turnpike was Anna Blessing Anthony (sixth from left). After graduating from Ravena High School, she attended a summer session at the Oneonta Normal School. That fall, at the age of 18, she was paid $15 weekly to teach at the Dunnsville School. On her first day, the children tested her mettle by stuffing a dead mouse in her desk drawer.

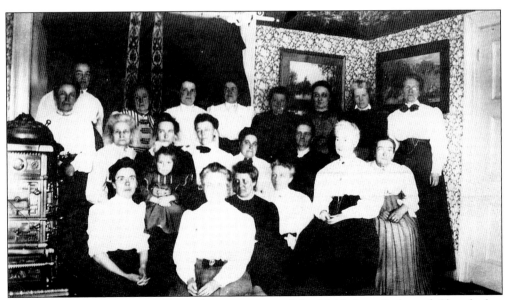

The Ladies' Social Union, a women's organization of the Helderberg Reformed Church that met at various members' homes, gathered at the Coss House in Fullers. The ladies appreciated the opportunity for a visit and leisurely chat, but had the more serious purpose of raising funds for their church. Note the c. 1900 interior, especially the parlor stove.

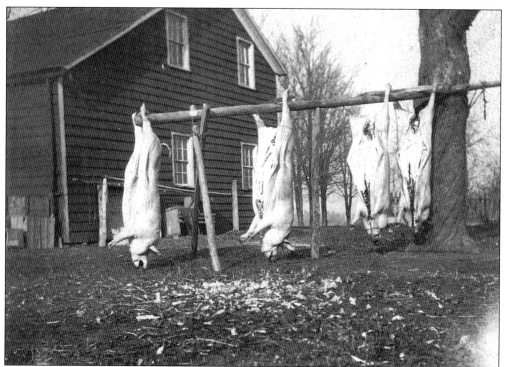

Perhaps unsettling to the eyes of squeamish modern viewers, this *c.* 1915 scene of slaughtered pigs hanging on the Blessing Farm, waiting to be cut up and smoked in the farm's smokehouse, was a common sight in late autumn on Guilderland's farms. Local farm families supplied most of their own foodstuffs, and the hams, bacon, sausages, and headcheese were welcome additions to their diet.

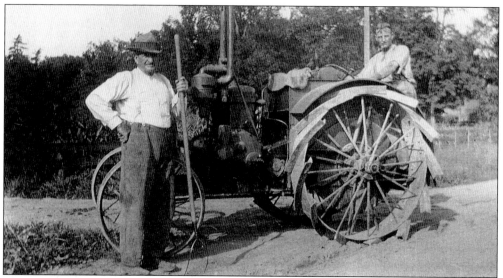

The old and new are evident in this picture taken on the Blessing Farm in Fullers. Martin Blessing (on the left) clings to his pitchfork, an implement used by generations of local farmers, while his son Jake stands ready to use their early tractor to quickly do chores that would have taken hours with a horse or by hand.

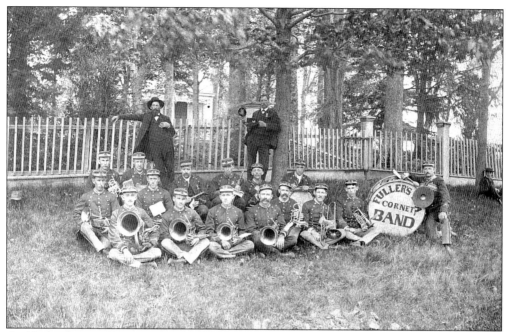

Guilderland's town band tradition got its start in the 19th century with the formation of cornet bands in Fullers and Knowersville. They performed at patriotic events and parades on Memorial Day and July Fourth.

The grade level crossing at Fullers became extremely dangerous with increased auto traffic in the 1920s. In 1927, a trestle was constructed and the highway was lowered to alleviate the problem. Within a few years, the second high trestle was erected, supposedly to aid locomotives pulling heavy trains up the steep grade at Frenchs Hollow.

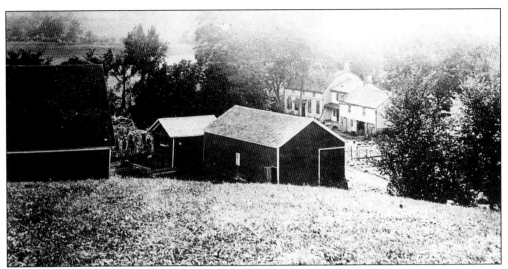

Col. Abraham Wemple's farm, located back from the turnpike west of Fullers, was nestled on the fertile flats bordering the Normanskill. Wemple, an esteemed Revolutionary War hero, was a prosperous farmer. His home was constructed in 1760 from bricks made of clay dug from the nearby banks of the Normanskill. When the Watervliet Reservoir was created, the house was demolished and the once productive fields were flooded.

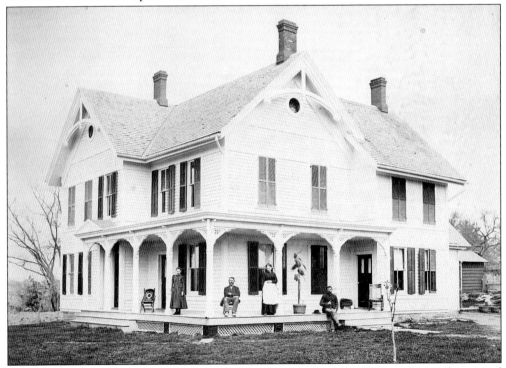

Sharps Corners was the name given to the intersection where the Western Turnpike crossed the road to Schenectady, now Route 158. Members of the Sharp family owned houses near each corner. The one pictured here is the Sharp-Jeffers House, standing west of the corners. It was one of many Guilderland homes photographed with their owners by the Northern Survey Company of Albany during the last quarter of the 19th century.

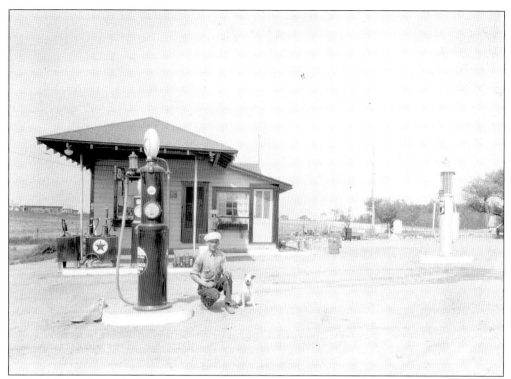

By the 1920s, Sharps Corners was on a heavily traveled east-west route. It was crossed by a well-traveled local road that was the perfect location for a gas station. Al and Eleanor Folke opened this Texaco station on the northeast corner of the intersection in 1925. In this early view, Folke poses by a gas pump shortly after the station opened.

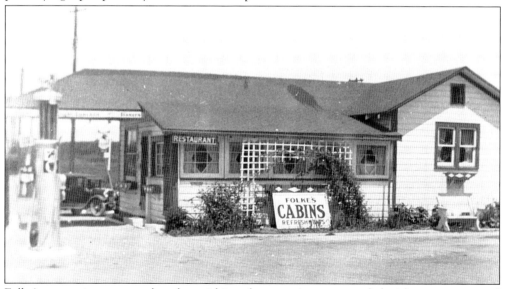

Folke's gas station prospered so that within a few years it was expanded with a restaurant and cabins. The rose-covered trellis and flowers added a homey touch. The Folkes operated their business at this location for over 40 years. The building has been converted to a residence at the northeast corner of Routes 20 and 158, and some cabins still remain.

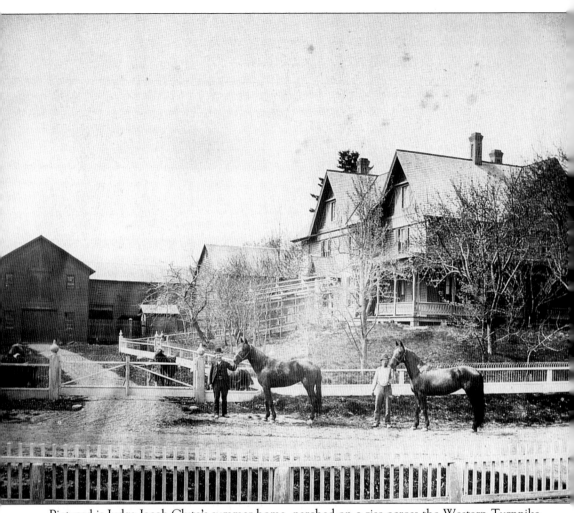

Pictured is Judge Jacob Clute's summer home, perched on a rise across the Western Turnpike. Judge Clute raised fine carriage horses on this working farm, which was run year round by his brother-in-law, Billy Moran (right). Charles Decker Sr., a neighbor, stands at left. Judge Clute's niece, Ina Clute, married a member of the Sharp family and eventually inherited the property. The house and barns survive today on the south side of Route 20.

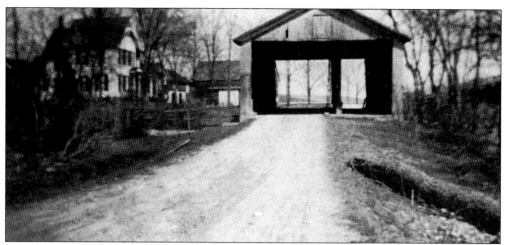

Early in the 19th century, a covered bridge carrying the Western Turnpike over the Normanskill was constructed just west of Sharps Corners. Road machinery and supplies were stored in the narrow half. Here, the view is to the east, toward Fullers, and the house on the left is the Sharp-Jeffers House. The bridge was removed c. 1922 to accommodate the trucks and buses that had begun to use the road.

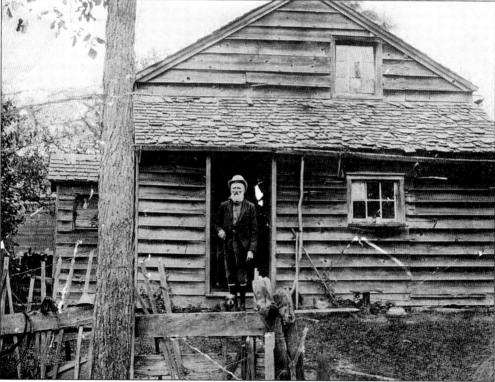

Living among Guilderland's many prosperous farmers and successful businessmen and craftsmen were those who had difficulty making ends meet. Their dwellings were seldom recorded and have long since disappeared, along with memories of their owners. This man, however, did have one precious possession: his little dog, which he carefully leashed. The house was located west of Sharps Corners, along the Western Turnpike.

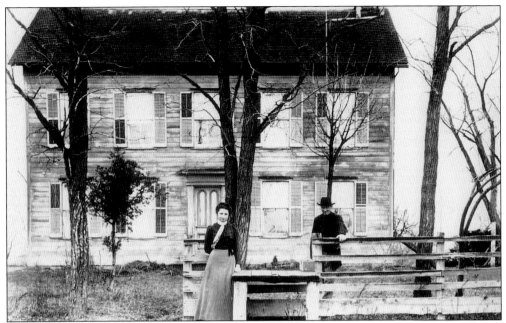

Miss Belle Davis, a teacher in the Dunnsville District #2 School, poses with her father in front of their home, located on the turnpike, one mile east of Dunnsville. When the house burned in 1912, a valuable landmark was lost; the building was an inn built many years before, when the Western Turnpike was a heavily traveled route to the west.

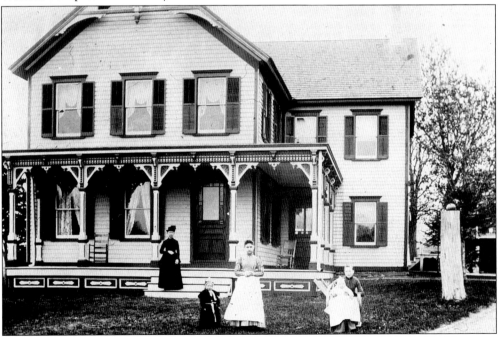

Casper Wagner's farmhouse was rebuilt in 1872, giving it what was then an up-to-date Victorian look, sporting elaborate millwork and trim. There was obviously a multi-color paint scheme, which was typical of the time. The house and farm were located on the Western Turnpike, east of Dunnsville Road.

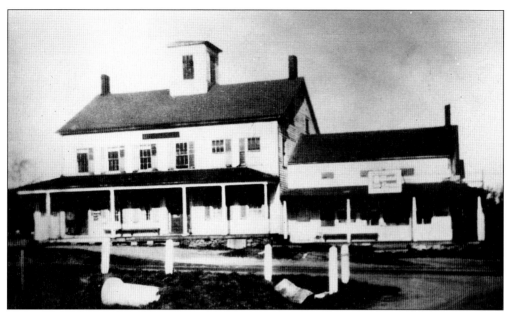

Christopher Dunn, an early landowner in the western part of Guilderland along the turnpike, was not only a tavern keeper, but gained statewide recognition as a progressive agriculturist in the 1830s. The small hamlet that developed in this area became known as Dunnsville and boasted two taverns, a store, two blacksmiths, a school, a post office, and a doctor's office by the end of the 19th century. Pictured is the Dunnsville Hotel, built in the mid-1800s. It was later used to house the Gifford Grange Hall.

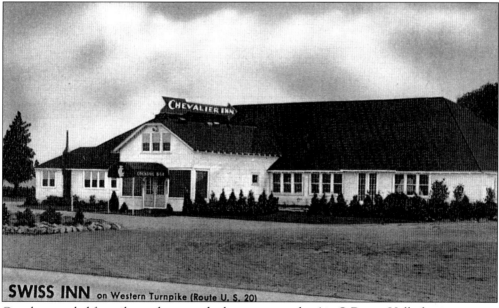

Couples traveled for miles to dance to the latest tune at the Air-O Dance Hall after its opening in 1930 on the Western Turnpike in Dunnsville. Unknowns such as "The Commanders" as well as popular musicians Rudy Vallee, Benny Goodman, and Jimmy Dorsey played at the crowded night spot. Wartime gas rationing closed the dance hall, but it later reopened as the Swiss Inn and stayed in business until it was destroyed by fire in 1972.

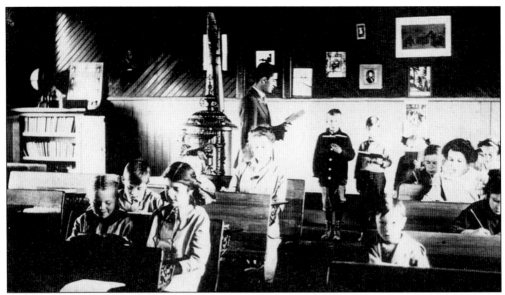

In a one-room school, *c.* 1915, self-discipline was expected of children regardless of age. Here, students at Dunnsville District #2 School quietly occupy themselves while the teacher works with small groups of children of varying ages and abilities. Equipment was simple: a pot belly stove, desks bolted to the floor, a blackboard, and a single bookcase that held the entire school library.

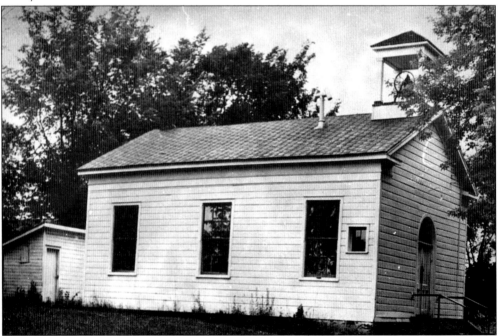

By 1876, Dunnsville's school had been relocated across Dunnsville Road from its original site. It remained in use at the new site until 1953. A teacher there for the last quarter century, Mrs. Ruth Lawyer, remembered modern technology coming to the one-room schoolhouse: "a radio to get educational programs, a victrola for music appreciation, a slide machine to help us learn of other countries." After 1953, the building became a private residence.

Four

GUILDERLAND CENTER AND FRENCHS HOLLOW

Few who drive Guilderland Center's Route 146 can visualize it as Schoharie Road, the dirt path trekked by German Palatines on their way to Schoharie in the 1750s, or later as the improved Schoharie Plank Road, traveled by stagecoaches and wagons. By the close of the 19th century, the road had simply become Main Street, lined by residences, a school, two churches, taverns, and various businesses, including a cigar factory. Building a railroad in 1865 helped spur the growth of the community.

By then, Guilderland Center was a respectable hamlet, unlike earlier times when people called it "Bangall" due to the "influence of rum, horse racing, and rough manners, once too prevalent there." Today "Bangall" has become an affectionate nickname for what is now a quiet, residential community. The dirt path through the wilderness has become the heavily traveled Route 146, but the old buildings on either side still retain a flavor of the past.

Nearby, over Frenchs Mills Road, was Frenchs Hollow, site of Peter Broeck's 1795 cloth works. Some other mills were built, and for a brief time, the area showed promise as an early-19th-century manufacturing center. Years of slow decline followed, and no trace remains of this early settlement.

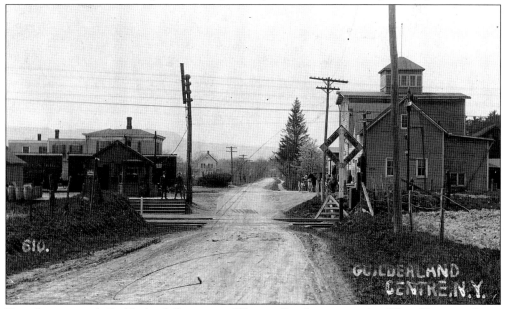

Travelers entered Guilderland Center on Wagner Road, crossing the West Shore tracks at grade level. After several auto fatalities at this crossing, the road was realigned and the Route 146 overpass was constructed in 1927.

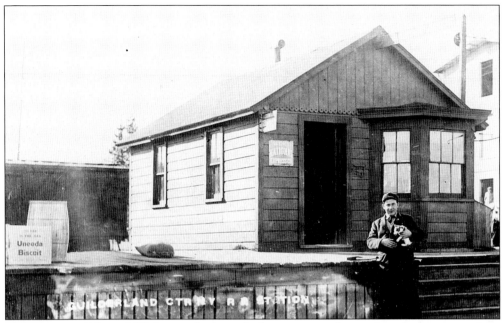

Perhaps young Edmund Witherwax had just laid a penny on the track and was waiting for a freight to come through to flatten his coin; this was a favorite activity of young fellows in his day. Even though Guilderland Center was on the mainline of the West Shore, it rated only the small station shown here c. 1910, where through the bay window observers could watch the telegrapher at work. Hurst's feed mill is visible on the right, across the main road.

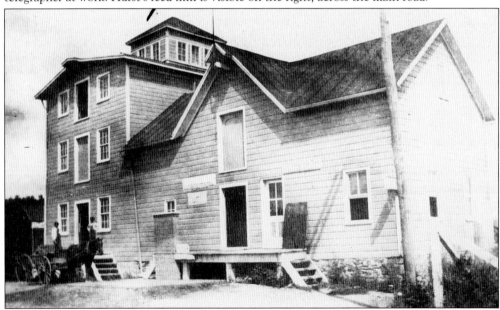

C.J. Hurst's feed mill was one of several mills in Guilderland, and it found a ready market among farmers who needed the animal feed, fertilizers, seed, and other farm supplies sold there. By the 1920s, Hurst also advertised coal, asphalt roofing, tires and tubes, oil and grease, and Overland Automobiles. When the mill burned in a spectacular fire one night in August 1926, witnesses said the glow could be seen for miles. The Route 146 overpass was built over this site.

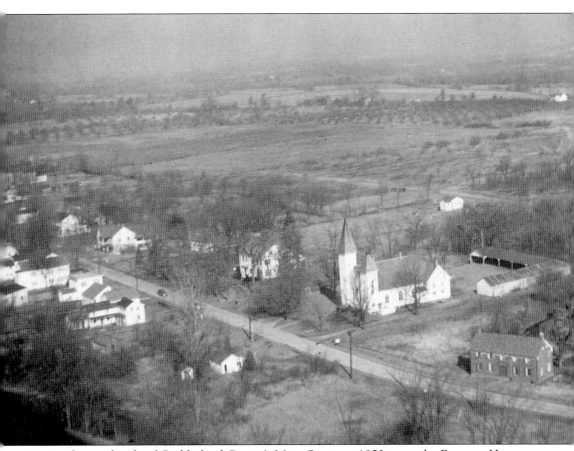

Lining the north side of Guilderland Center's Main Street, c. 1950, were the Freeman House, the Helderberg Reformed Church (with the horse sheds still intact), the Mynderse-Frederick House, Joe Banks' tavern, private homes, and, at the far left, St. Mark's Church. Across the street from the Reformed church was a gas station, then private homes. The peak of Empie's store can be seen beyond the large, rectangular house, which was moved around the corner to School Road when the store was demolished. It was replaced by a gas station in the early 1970s.

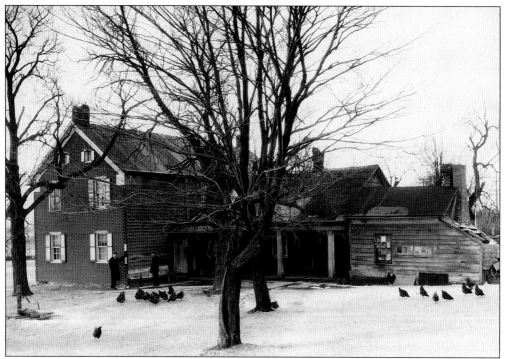

The oldest existing frame building in Guilderland is the red clapboard Freeman House, which was built c. 1734 at 429 Route 146. In this 1937 view, Edward P. Crounse stands to the right of his farmhouse while it is being recorded for the Historic American Buildings Survey. Since restored, the Dutch door in front is just one of its many original architectural details.

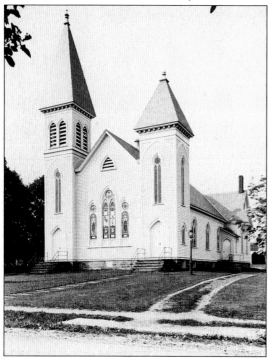

The Helderberg Reformed Church, seen here c. 1910, opened its doors in 1896 when it replaced the Gamble Church at Osborn Corners. Stained-glass windows, the chandelier, and the bell given in 1845 by the Ladies Benevolent Society were incorporated into this building. It burned in 1986 and had to be razed. The bell survived the flames to ring again in the new church.

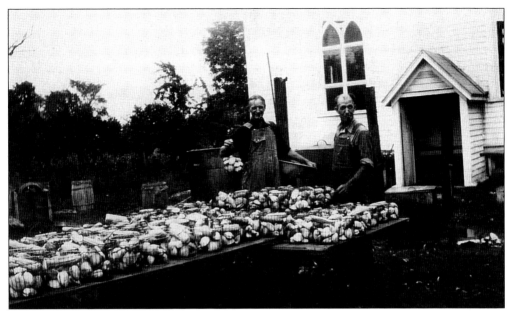

Both the St. Mark's Lutheran and Helderberg Reformed Churches sponsored events such as ice cream socials and dinners. Helderberg's dinners were described in the *Altamont Enterprise* in 1912 as having "a wide reputation owing to the excellent spreads they set up," and their famous clam bakes drew large crowds. In this *c.* 1932 view, Jacob Blessing (left) and Lloyd Coss are set to steam baskets of clams and corn in huge vats behind the church.

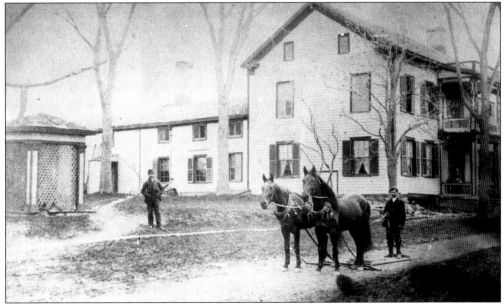

The Mynderse-Frederick House, one of Guilderland's early taverns, was built on the Schoharie Road in 1802 by Nicholas Mynderse. Three generations of the Frederick family continued tavern operations here until 1917, when the building became their private home. William Frederick and William Frederick Jr. are pictured in this *c.* 1890 photograph. Note the Victorian porches and the latticed well house, both since removed. The entrance to the tap room is to the left of the porch.

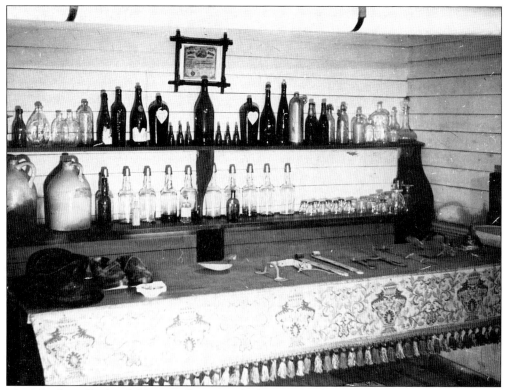

The Mynderse-Frederick House still retains the bar in what had once been its cellar tap room. Above the bar, for many years, hung the banner carried by the "Wide Awakes," an organization of backers of Lincoln in the 1860 election who were very active in Guilderland. Since 1972, the Mynderse-Frederick House has been a house museum owned by the Town of Guilderland.

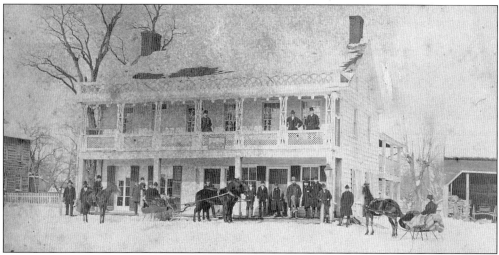

Michael Frederick's Center House, built c. 1849, was a popular rest stop for Schoharie and Albany Stage Coach passengers traveling the Schoharie Plank Road. A convivial gathering place, the bar was occasionally the scene of the fisticuffs that gave "Bangall" its reputation, while in the spacious upstairs ballroom, partygoers often had lively dances. The tavern, shown here c. 1890, continued to be a center for local social life for another 80 years.

Remodeled and modernized early in the 20th century, the Center House continued to be a tavern until c. 1970. Seymour Borst was its proprietor in the 1920s when this photograph was taken; in the 1930s, the tavern was owned by Joseph Banks. Under his management, the tavern attracted not only the local residents, but out-of-towners for parties and dances. The tavern was demolished by a developer, and Park Guilderland's entrance is located on the site today.

In this c. 1915 view looking toward Altamont, Main Street is little more than a lightly traveled dirt road. Borst's Hotel, later known as Banks' Tavern, is on the right. At the far left are the porch columns of Petinger's General Store, which is the present site of a gas station. The motor cycle is parked where School Road (County Route 202) leads to Guilderland High School. The houses located west of School Road remain.

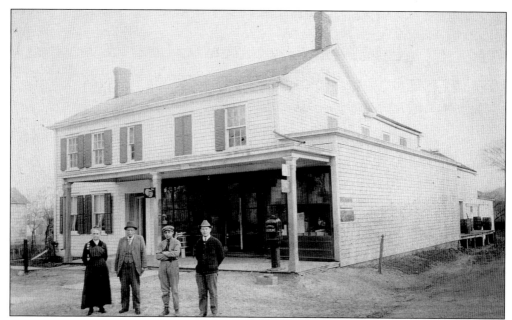

Petinger's General Store was a fixture on the southeast corner of Main Street and School Road. It was the first gas station in Guilderland Center. The gas pump at the end of the porch served the two or three cars that passed by daily when this picture was taken *c.* 1915. Gasoline was brought from Albany in a wagon pulled by a mule team. Helen, Philip Sr., Philip Petinger III, and John Ladd are in pictured in front. In later years, Luther Empie ran the store.

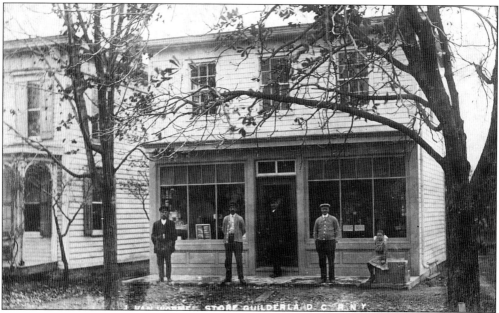

Early in this century, Guilderland Center's other general store was owned by Fred and John Van Wormer. In those days of postal patronage, when a Democratic president was elected, the post office moved to their store. Otherwise, it was up the street at Petinger's store. The men in this view are unidentified. The little girl is Margaret Moak. The building, presently a residence at 468 Route 146, has changed significantly since the time of this picture.

Eyeing a snazzy motorcycle, Leon Van Wormer is seated in his rig on Main Street. On the left, just down the street, is the "old town hall." Acquired by the Town of Guilderland in 1915, it was never used for town offices; in those simpler days, office holders worked from their homes. The small shop on the right was formerly a shoe shop. In the distance is St. Mark's steeple.

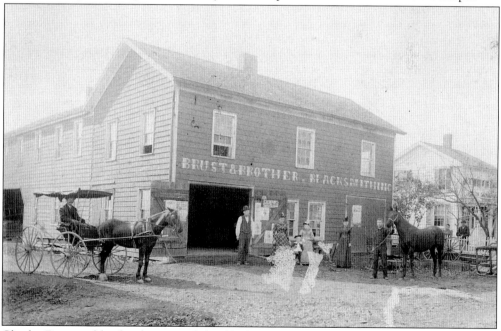

Charles Brust and his brother owned this blacksmith shop and wagon factory on Main Street c. 1885. Later, the building was used for auto dealers and their repair shops until it was removed c. 1920. The lane at the left of the building led from Black Creek to the farmhouse on the opposite bank. The house on the right burned in 1963. A newer home, located at 482 Route 146, presently stands at the former site of Brust's shop.

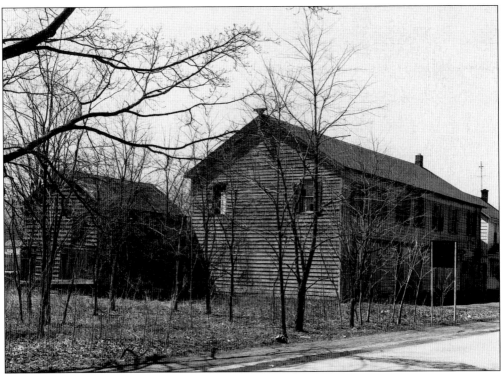

A century before this c. 1950 photo was taken, the old town hall was built on the south side of Main Street to serve as the horse shed for Fowler's Hotel. Upstairs was a large hall where such events as political caucuses, public meetings, firemen's dances, and school plays were held. Downstairs was the Guilderland Center Fire Department's first home and a storage area for the Guilderland Highway Department's equipment. The building was dismantled in 1958.

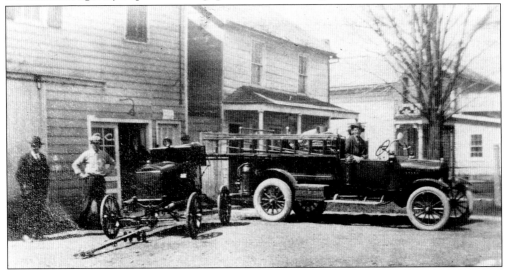

Founded in 1918, the Guilderland Center Fire Department's first piece of equipment was a two-wheeled chemical tanker cart, which firemen had to pull to the fire scene when signaled by the clanging of a sledge hammer against a locomotive tire. Here, in the mid-1920s, Chief John York stands beside the 1923 Village Queen pumper with a 1924 Model-T parked nearby.

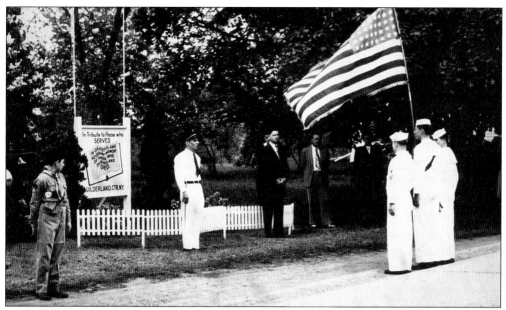

Traffic halted on Main Street in May 1949 for the dedication of Guilderland Center's World War II Memorial and Honor Roll. Pictured from left to right are unidentified scout, Donald Lawton, Rev. Floyd Nagel, and Charles Miller. John Martin is at left in the Honor Guard. The others are unidentified. A private home, located at 475 Route 146, stands today at the site of the memorial.

Helen Hurst posed for this photograph at a local Halloween party in 1925. Note the typical mid-1920s interior of the living room in George Hurst's home. The house still stands on Route 146.

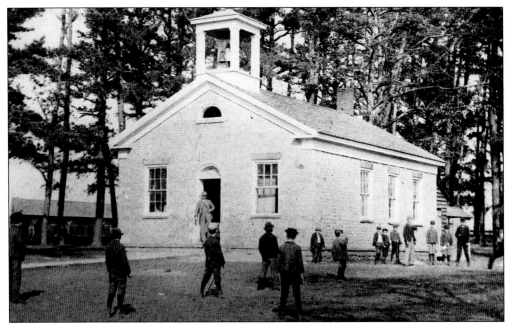

Children play outside the District #6 Cobblestone School under the watchful eye of their teacher in this *c.* 1900 view. Constructed in 1860, the building served as Guilderland Center's schoolhouse until 1941, when students began attending classes in Voorheesville. The building is located on the north side of Main Street and is still owned by the Guilderland Central School District.

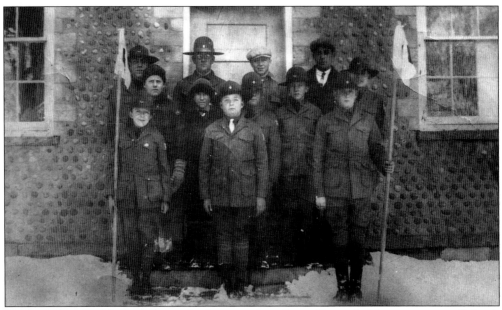

By the 1920s, Guilderland Center had its own Boy Scout Troop, led by scoutmaster Raleigh Moffett. Standing at attention in front of the Cobblestone School in this view are the following, from left to right: (front row) Roland Van Wormer, George Wedekind, and Bob Hurst; (middle row) unidentified, Arthur Frederick, unidentified, and Harold Gillespie; (back row) Curtis Doxsee, Moffett, Roy Frederick, Leland Van Auken, and Earl Doxsee.

St. Mark's Lutheran Church and horse sheds were new when this view was taken in 1875. Dedicated in 1872, the church, along with St. John's of Altamont, were successors to the old St. James below the Hellebergh, which had been located near the modern entrance to Fairview Cemetery. St. Mark's served the Lutherans until 1973, when the town leased it as a community center. The Berean Baptist congregation has returned the building to its original use as a church.

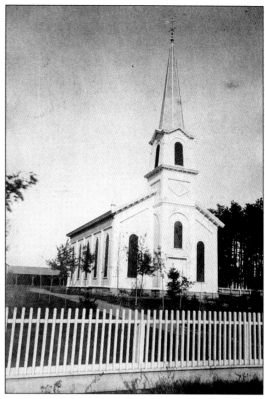

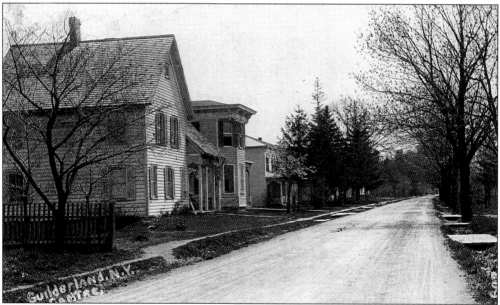

These three houses on the north side of Main Street look almost the same today as they did in 1910. When the Helderberg Reformed Church moved to Guilderland Center in 1896, the center house became the parsonage. Eventually, after being drastically remodeled, Hazel Reed began the Guilderland Center Nursing Home there in 1955. The current owner has returned it to its original architecture. These houses are at 495, 497, and 499 Route 146.

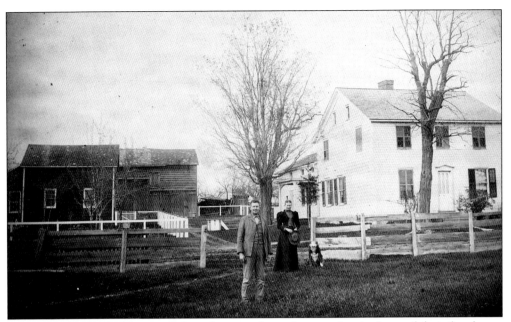

Mr. and Mrs. Charles Fares and their dog pose for a photographer in front of their farmhouse and barns on the north side of Main Street *c.* 1880. This was one of three working farms on that road in the hamlet. Note the privy beyond the tree; every house had one of those necessaries out back. The house and barns are located at 515 Route 146.

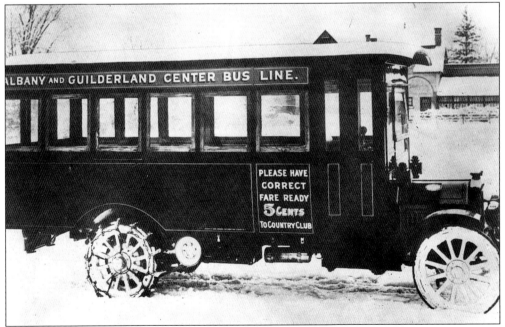

Since the West Shore Railroad did not go directly to Albany or Altamont, the introduction of bus service made life more convenient for Guilderland Center residents. DeWitt Main ran buses between Albany and Fonda's Corners, soon extending the route into Guilderland Center and Altamont. In this 1913 winter scene, note the chains on the back wheels, which were necessary to climb the hills to Altamont in the snow.

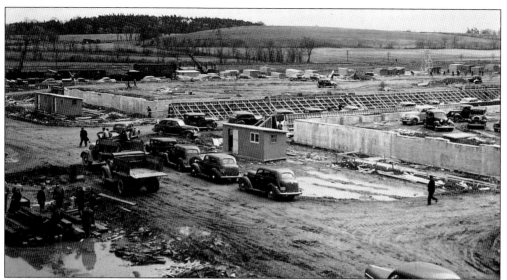

In the late 1930s, with the threat of possible U.S. involvement in the war growing more serious, the government began to establish military depots for storage and shipment of war materiel. After acquiring a large tract of farmland between Guilderland Center and Voorheesville along the West Shore tracks in 1941, construction began on the U.S. Army Engineering Depot, a National Defense Project. Here, warehouse three and four are taking shape. Expanded during the Korean War, the depot later became Northeastern Industrial Park.

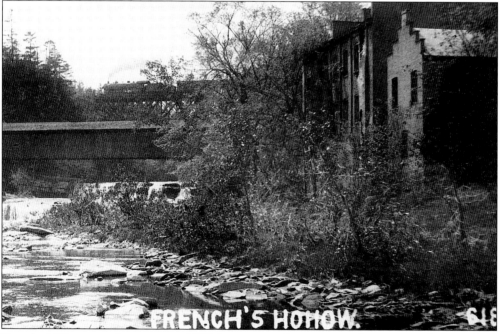

Frenchs Mills was a ghost town c. 1910. Long ago a thriving manufacturing settlement along the Normanskill at Frenchs Hollow, not far from Guilderland Center, it once had a gristmill, sawmill, covered bridge, and the large cloth factory seen here. When the railroad was built in 1865, it bypassed the Hollow, crossing on a trestle. The old mills and covered bridge were demolished one by one. By 1933, all were gone.

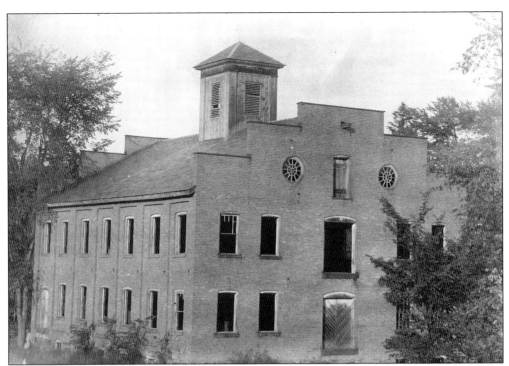

Utilizing the power of the rushing Normanskill, Abel French built this woolen mill *c.* 1800. By the 1860s, the factory was no longer in production. For many years, however, the community made use of the building for church suppers, dances, early Methodist meetings, and other gatherings. Derelict by the time this photo was taken *c.* 1890, the building was razed in 1917 (when the Watervliet Reservoir was created) and it became the site of the pumping station.

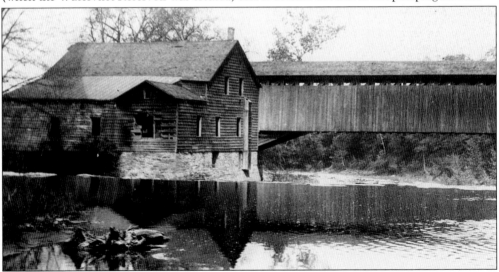

The sound of mill wheels grinding grain into flour at the Globe, later Spawn's Grist Mill, once echoed down the Hollow. Competition from cheap Midwestern flour forced local mills out of business so that by the time this photo was taken *c.* 1900, the mill had been abandoned for years. The old building was dismantled in 1925, and the new bridge was erected in 1933. It crossed the Normanskill over the site of the old mill.

A corner of the old cloth factory is visible on the right in this *c.* 1890 view of housing at Frenchs Mills. Children living here hiked out to the Fullers School while churchgoers either attended Guilderland Center churches or went to the Parkers Corners Methodist Church. All of these buildings along Frenchs Mills Road had disappeared by 1917, when the reservoir pumping station was built.

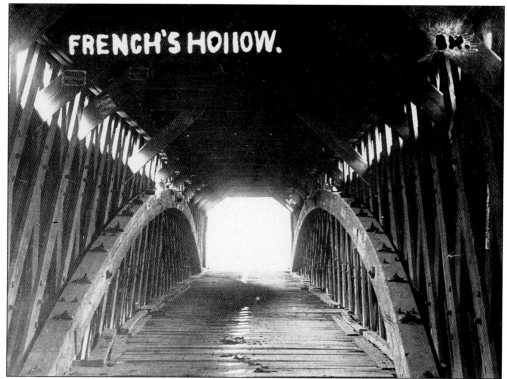

FRENCH'S HOLLOW.

The interior structure of Frenchs Hollow covered bridge magnified the sounds of horses' hoofs and wagon wheels to reverberate like thunder; it was a sound that could be heard some distance away. Henry Witherwax built the 162-foot, 8-inch span to carry Frenchs Mills Road over the Normanskill in 1869. Still in fine condition when it was dismantled in 1932, the bridge had become inadequate for the increasing auto traffic.

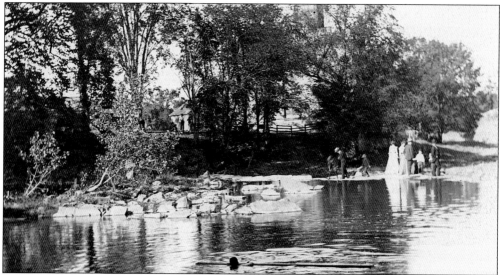

Until well into the 20th century, folks came from miles around to swim, fish, and picnic at Frenchs Hollow. When this photo was taken c. 1910, casual dress was still quite formal. Note the tower of Frenchs Mill behind the trees.

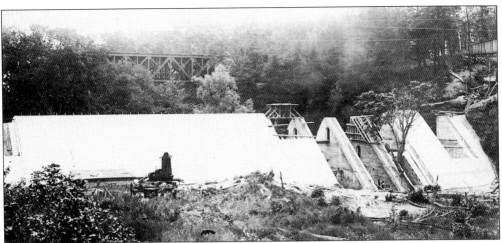

Shortly after Watervliet Reservoir was created by damming up the Normanskill in 1917, all vestiges of the Frenchs Mills 19th-century manufacturing settlement disappeared. The dam was located upstream from the West Shore Railroad trestle, which can be seen in the background of this picture of the dam under construction. Beyond the trestle would have been the abandoned gristmill, covered bridge, factory building, and old houses. Water from the reservoir still supplies Watervliet and provides part of Guilderland's town water.

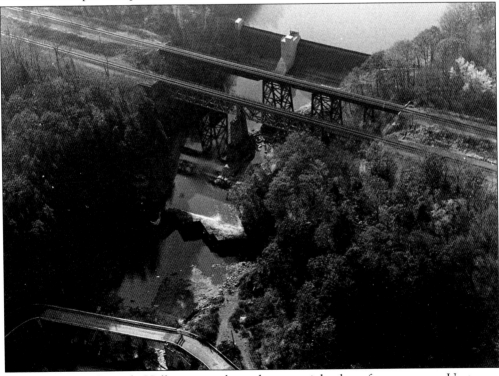

This aerial view of Frenchs Hollow ravine shows the area as it has been for many years. Upstream, much farmland was flooded when the Normanskill was dammed in 1917. Heavy freight trains cross the sturdy trestles that replaced the original wooden one erected by the Saratoga and Hudson Railroad in 1865. The 1933 Frenchs Mills Road Bridge has been declared unsafe and is now closed to traffic.

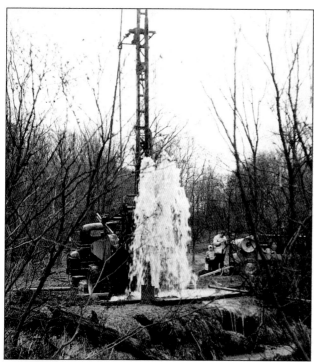

This well was described as a "gusher" when well driller Richard Ferriaoli first tapped into an underground water channel near Frenchs Mill Road in October 1964. Town officials were elated when it produced 540 gallons per minute, hoping this would be a major step in creating a public water supply. Unfortunately, when test results were in, the water proved to have a high iron content with additional minerals, making treatment and public use impractical.

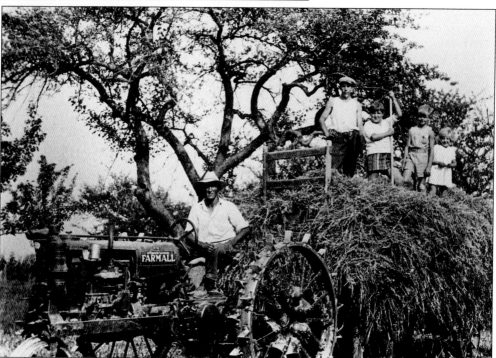

One of the old family farms in the Frenchs Hollow area was the Brandow Farm on Frenchs Hollow Road. Getting a lift atop a hay wagon was always a treat for farm children. Pictured from left to right in this 1936 snapshot are Eleanor Smith, William Henry Brandow Jr., and Helen Brandow Coughtry. The two men are unidentified.

Five

ALTAMONT AND ALTAMONT FAIR

The significant historical background of Altamont is an important part of the town of Guilderland's history. The notations on the earliest Palatine settlers in the 1740s, the Anti-Rent Wars of the 1830s, the village railroad history, and the beginnings of an agricultural fairground make the small hamlet that has had seven names unique.

The Manor of Rennselaerwyck, Helleberg, West Manor, West Guilderland, Knowersville, Knowers, and finally, in 1887, Altamont has retained its early American heritage. A main street lined with gracious Victorian homes, a railroad station with tracks that run through the middle of the village, and a fairground that has seen the horse and carriage give way to the many-hued motor cars that fill the parking lot every August are reminders of Altamont's history.

The incorporation of Altamont in 1890, under the direction of the village's first mayor, Hiram Griggs, named specific boundaries. Historic houses such as the Knower House and the Inn of Jacob Crounse, located in the "old village" of Knowersville, and a section of the Altamont Fair Grounds are not included within the village boundaries. They are included in this chapter because of their close proximity to the village.

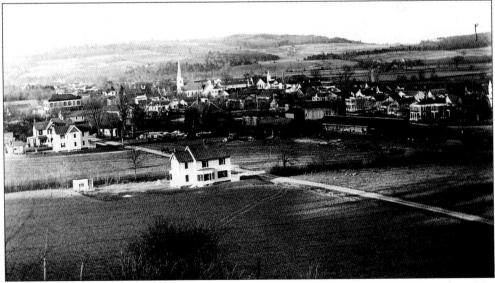

An idyllic small village, Altamont represents typical Americana c. 1900. The steeples of St. John's Lutheran Church and the Altamont Reformed Church can be seen. The building with seven windows on the top floor is the old Altamont Hotel. In the center is the newly erected gazebo on the village green.

85

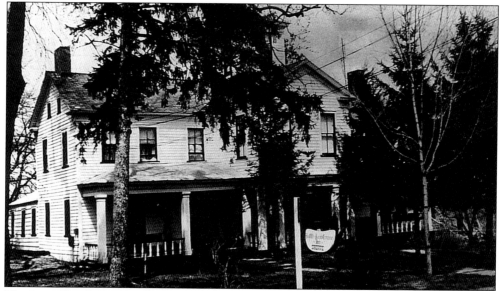

The Inn of Jacob Crounse, built in 1833 on Route 146 in Altamont, was once a halfway house and tavern where pioneer guests found bed and board and where horses were changed on the Schoharie-Albany mail and stagecoach run. Jacob's Inn was built on a foundation of bluestone from Howe's Cavern and lumber from the Helderberg forests. Located in the "old village of Knowersville," an antique shop run by Charles and Gigi Mealy now occupies the historic inn.

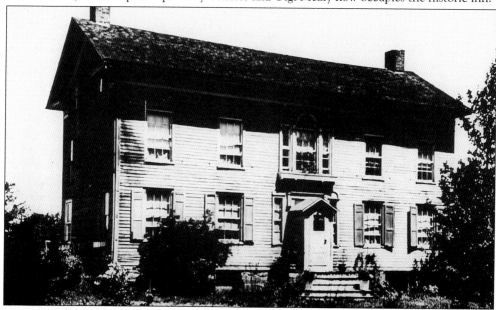

Pictured in this c. 1915 view is the Knower House, located on Route 146 north of Gun Club Road. In "old Knowersville," it has been an historic landmark since 1800. Benjamin Knower began his business as a hatter and a mechanic. His fashionable "Knower hats" were waterproofed by a secret process of immersion in the Bozenkill Creek behind his mansion. Through his personal integrity, he became a bank president and the secretary of the New York State Treasury. The wedding of Knower's daughter Cornelia to Gov. William L. Marcy took place on this historic site.

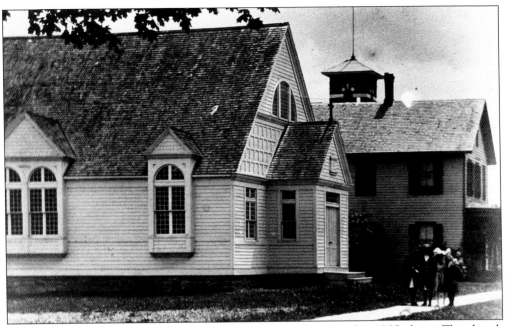

Youngsters gather outside St. Lucy's Church on Grand Street in this 1905 photo. The church was built in 1888 through the efforts of Mrs. William (Lucy) Cassidy, who owned a large mansion on the hill above Altamont. The name was going to be St. Anthony's, but it was changed to honor the founder's patron saint. History records also reveal that Mrs. Cassidy was instrumental in having the name of Knowersville changed to Altamont. The Altamont School tower can be seen in the background.

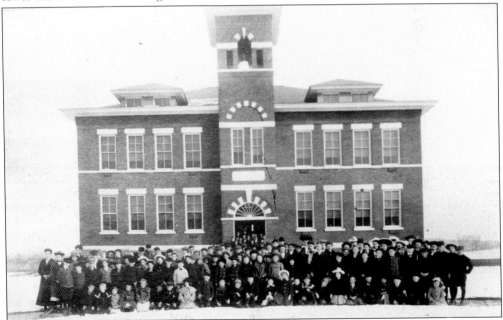

Built in 1902, the new Altamont High School on Grand Street had its first year of classes in 1903. The building, demolished in 1955, once stood in front of the site of the present Altamont Elementary School.

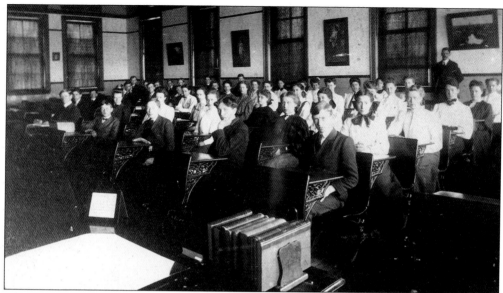

Altamont High School had been open just two years when this photo was taken in 1904. Principal Arthur Boothby and students pause from their studies for the camera to record a moment in history. Because it was the only high school between Albany and Schoharie, it attracted a number of students; out-of-town students often boarded with Altamont families, while commuters purchased $3-per-month tickets to ride the D&H train from Voorheesville or Delanson.

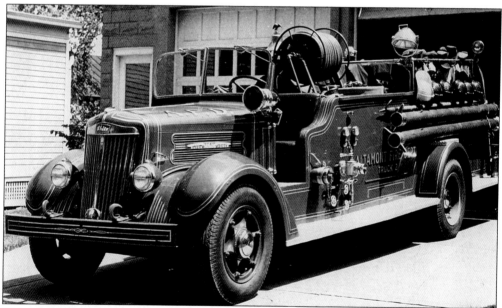

This 1941 White Fire Engine with a water pump was Altamont's first "modern" fire-fighting apparatus. The department was created in May 1893, and the pumper was housed on Maple Street. Altamont's first big fire occurred in 1886, when six buildings on Maple Avenue burned to the ground. A group of town residents fought the blaze with buckets, wet blankets, and shovels. Today, the fire company operates with its new equipment from a new building on Main Street.

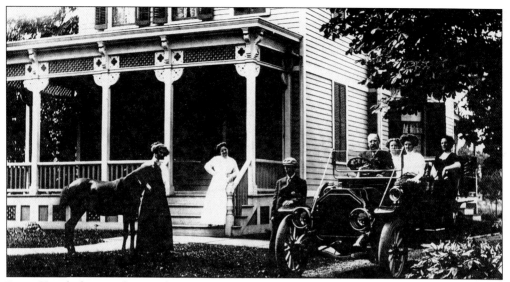

James Keenholts, seen here at the wheel, shows off his new Buick in the driveway of his 174 Main Street home. In this 1909 photo, Anna Keenholts (Hilton) sits behind her "Papa" with her Aunt Myra. Mrs. Edna Poland is seated beside Mr. Keenholts. Ella Keenholts (Vanderpool) stands by the pony, "Fanny," while her mother, Mrs. James Keenholts, is on the front steps. The family chauffeur, Mr. Kaley, stands by the car. Records tell us that Mr. Keenholts, who never learned to drive, ran a livery and boarding stable on Prospect Avenue, at the present location of Agway.

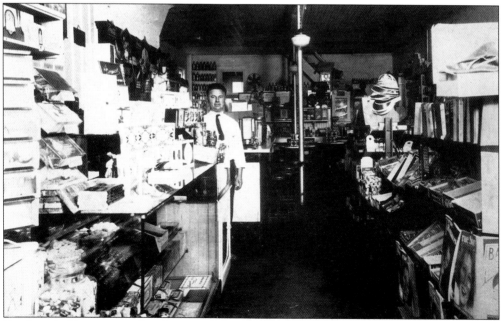

Stephen A. Venear owned and operated the Altamont Pharmacy on Main Street from 1926 to 1954. The pharmacy was the oldest in the area, dating back to 1888, when George Davenport and Cyrus Frederick were the owners. In addition to prescriptions, the pharmacy was a mainstay for Altamont residents; it also carried magazines, candy, sundries, and served treats at the ice cream and soda counter.

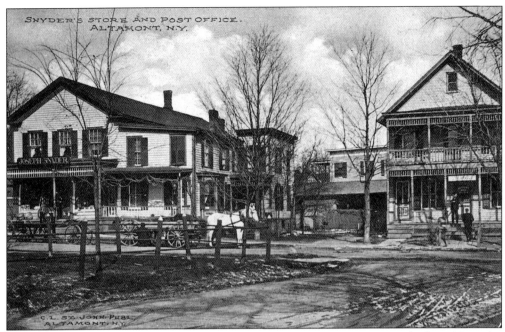

Snyder's store on Main Street gives full visual meaning to Altamont's early days. Note the team of horses used for deliveries. Snyder's became the A&P food store, and then passed through several owners. Today, the Hungerford Bagel Shop occupies the building. The building on the right once housed, at different times, the *Altamont Enterprise*, the Altamont Post Office (from 1901 to 1914), and the Altamont Pharmacy. The building is currently owned by Gilbert DeLucia.

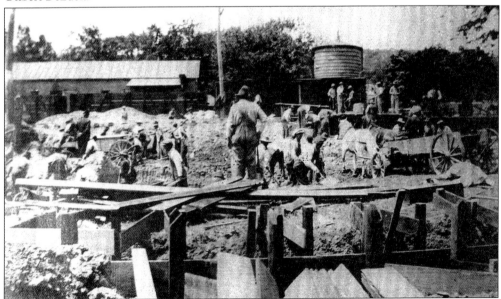

In this *c.* 1890 view, village workers assist D&H Railroad men in building the turntable that led the Altamont "Scoot" through the D&H Engine House and back on tracks for a return trip to Albany via Meadowdale and Voorheesville. The turntable was on the site of the present Altamont Post Office.

Delaware and Hudson
COMPANY.

TIME TABLE OF TRAINS
BETWEEN

ALBANY,

ELSMERE,

DELMAR,

SLINGERLANDS,

FONT GROVE,

VOORHEESVILLE,

MEADOWDALE and

ALTAMONT,

In Effect January 3rd, 1909

J. W. BURDICK, Passenger Traffic Manager

A. A. HEARD, General Passenger Agent.

18

TICKETS

FOR TRAINS NAMED HEREIN ARE ON SALE BETWEEN THE FOLLOWING POINTS AT RATES NAMED :

BETWEEN ALBANY AND	One way Fare	Round Trip Fare	60 Trip Monthly Commutation Tickets	50 Trip Family Commutation Tickets	46 Trip Monthly School Tickets
†Elsmere	.15	.25	$4.25	$5.00	$2.30
Delmar	.18	.31	4.50	5.25	2.50
Slingerlands	.20	.35	4.75	7.00	2.75
Voorheesville	.33	.61	5.50	9.65	3.50
Meadowdale	.42	.79	6.75	12.25	3.75
Altamont	.50	.95	7.00	15.75	4.00

† On sale at Albany only.

60 trip monthly commutation tickets and 46 trip school tickets are good for one month and only for the individual use of the person in whose name they are issued.

50 trip family ticket is limited to four months from date of sale and is good for the passage of the person in whose name it is issued, any dependent member of his or her family, any visitor to the family, or domestic servant employed therein.

Purchasers of commutation tickets will find the ticket office established in the D. & H. building a great convenience and are recommended to secure their monthly tickets, if purchased in Albany, there, so as to relieve the congestion at the Union Station.

12-23-1908-5M-1138

This is a copy of a D&H Railroad timetable.

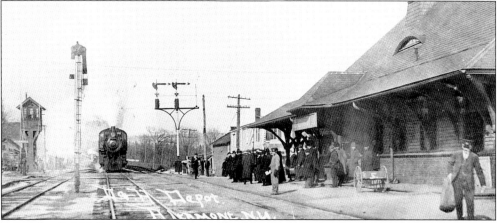

From the D&H Railroad Station in Altamont, 10 trains traveled daily to Albany via Meadowdale, Voorheesville, Slingerlands, and Delmar. Commuter trains turned around in the village roundhouse on the site of the present post office. Note the switchman's square, wooden shelter with windows on all sides and perched on a tower. It protected the switchman from inclement weather as he engineered oncoming trains to sidings to unload freight and passengers, in order to keep the main track clear for express trains. The switch hut is being restored and was displayed at this year's Altamont Fair.

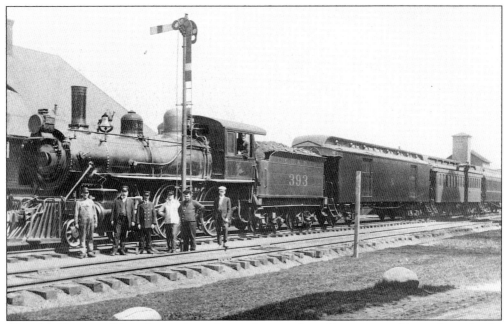

The old Altamont "Scoot" roared up the tracks into the village, gave a blast of its whistle, and drew into the train station to discharge passengers from four wooden coaches each day at 5:45 p.m. Engine #393, built by the Dickson Locomotive Works in 1895, and the crew were a familiar sight to town residents. The train, which had carried commuters from the little town at the foot of the Helderbergs daily to their work in Albany, made its last run on April 30, 1930.

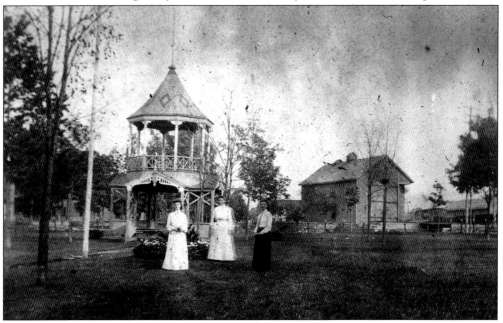

The Altamont Village Park with its ornate pagoda and bandstand create a lovely Victorian scene. The park was completely enclosed by an iron-pipe fence (background) and was the property of the D&H Railroad until deeded over to the village. The D&H Engine House in the background was built c. 1895. The three ladies enjoying the day remain unidentified.

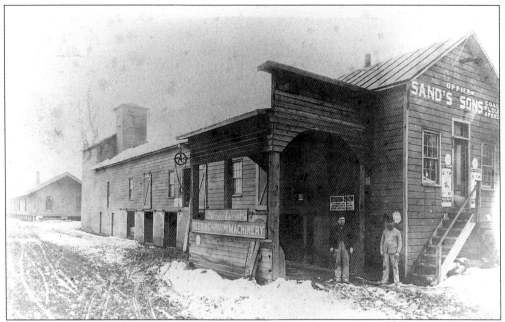

The Sand and Son Coal, Flour, and Feed Mill was operated by the Sand Brothers, who owned the feed and grain mill, a soda manufacturing company, and an automobile sales venture in Altamont. Montford Sand, a one-time village mayor, was one of the leaders in the village's incorporation and the owner of the Altamont Illuminating Company, which brought streetlights to Altamont c. 1902.

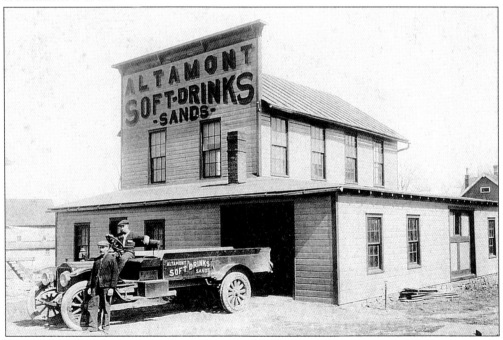

Previously a shirt factory, the Sand's Bottling Works was a thriving turn-of-the-century soda and sarsaparilla business. Owned by Montford Sand, the building was located at the end of Park Street and housed a dance hall upstairs, over the bottling works.

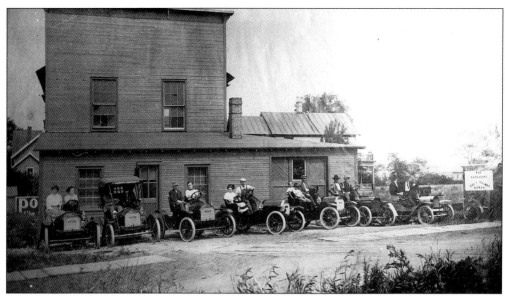

A line of Brush Runabouts in front of the Old Altamont Bottling Works, near the corner of Fairview Avenue and Park Street, get ready for a drive through the village in 1910. Brush cars were built from 1907 to 1912, with the Runabout a favorite model that sold for about $480 to $750. Late town historian Roger Keenholts wrote that Altamont residents used their Runabouts for delivering groceries and, weather permitting, the mail.

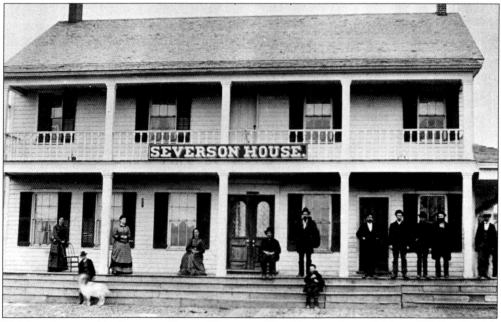

This hotel, erected in the new village of Knowersville (Altamont), was built in 1867 by George Severson, a great-grandson of one of the earliest settlers. Also known as the Union Hotel, and later the Commercial Hotel, it was run by Dutch Cornelius. The popular hostelry drew summer boarders from Albany and surrounding areas who sought the fresh air of the Helderbergs. The new D&H Railroad line near the hotel added to the mushrooming growth of the village and neighboring areas.

Mr. and Mrs. Charles Beebe pose for a formal photograph in their turn-of-the-century Altamont home. This rare interior photo with a piano and many wall hangings depicts the well-to-do status of the inhabitants. Mr. Beebe owned and operated Beebe's Harness Shop in the village.

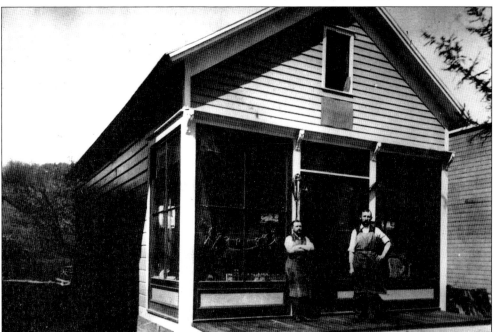

Frank Cowan, employee, and Charles V. Beebe, owner, pose for the camera in front of Beebe's Harness Shop at 119 Maple Avenue in 1895. Harnesses and riggings were repaired here, and carriages were repaired in a large barn-like building in the rear, also owned by Beebe. With the advent of the horseless carriage, the building housed the Keenholts Insurance Agency, operated by late town historian Roger Keenholts.

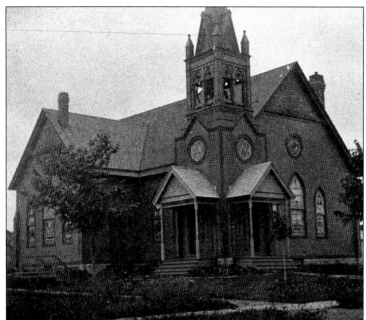

The Reformed Church began as a mission church in 1888 for summer residents, with services held by the Helderberg Reformed Church ministers. With a growing congregation, the Altamont Church split with the Helderberg Church in 1896 and built their church on Lincoln Avenue.

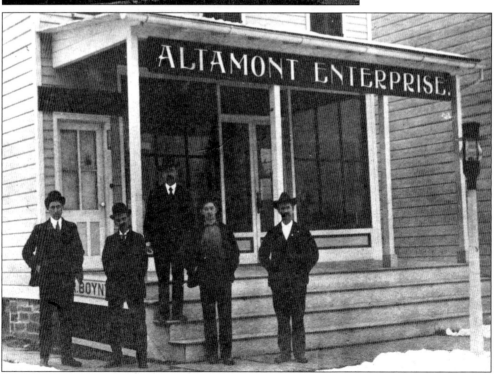

The Altamont Enterprise building at 123 Maple Avenue has seen many changes since this early 1900s photo. On July 26, 1884, the first edition of the *Knowersville Enterprise* was published by editor David H. Crowe. Crowe sold the paper to Jay Klock and J.B. Hilton within a year. Three years later, ownership came to John D. and Junius D. Ogsbury. When the village changed its name to Altamont, so did the paper. It became the *Altamont Enterprise*. The men in this photo are unidentified.

A 1960 photo at the *Altamont Enterprise* shows Marvin Vroman, part owner of the newspaper, seated at the hot-metal typesetting machine while James Gardner, typesetter, and James Pino, part owner, look on. James Gardner is now the owner and publisher of the weekly paper, which has been published continuously since 1884.

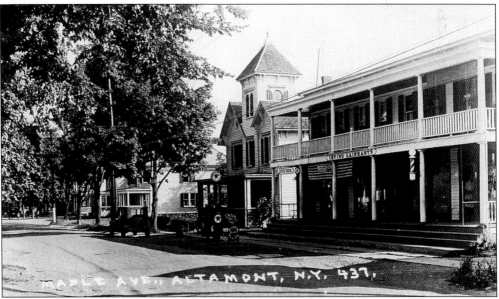

The Lainhart Building on Maple Avenue could be called Altamont's first "strip mall" of the early 1900s. It featured a news room, a barber shop, and an all-purpose general store. It became the social gathering place of the times. Next door, at 118–120 Maple Avenue, was the Joseph Gaglioti House. His descendants built and opened the Maplewood Restaurant on the adjoining property.

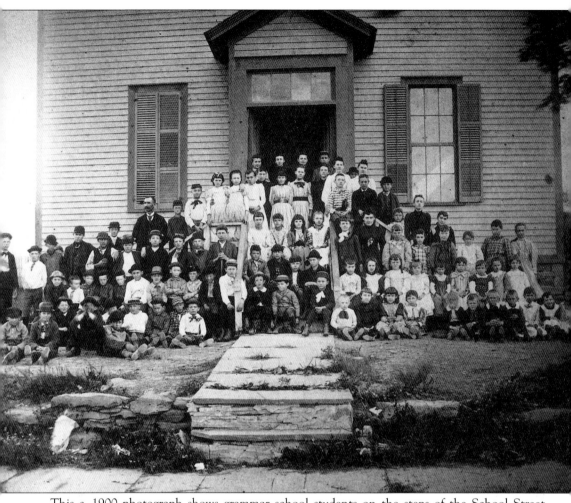

This *c.* 1900 photograph shows grammar school students on the steps of the School Street (Lincoln Avenue) public school building, located between the Temperance Lodge and the Altamont Reformed Church. In 1901, when the Altamont High School was to be built, the school was moved to 131 Maple Avenue. The structure now houses apartments. The teacher is unidentified.

Soon after the Revolutionary War, the seeds for the beginnings of the Lutheran Church were sown in Altamont. The mother church, St. James, was founded by German settlers, and their first church was built in 1787 near Fairview Cemetery. After 100 years, with a growing congregation, St. John's Lutheran Church was built on Maple Avenue in the village. St. John's celebrated its 125th anniversary in 1997.

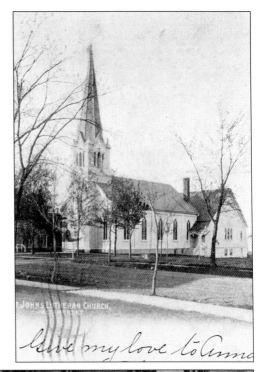

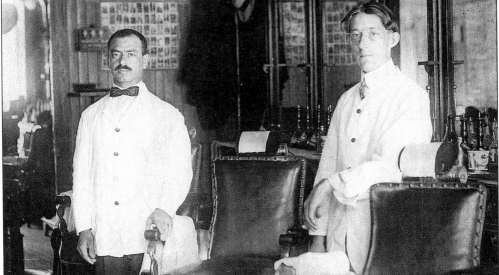

Joseph Gaglioti (with mustache) awaits customers in his barber shop in the Lainhart building. In the 1890s, when the Village of Altamont was incorporated, there were many thriving businesses, including a shoemaker, blacksmith, framer, cabinet maker, carriage repair shop, steam mill, drug store, furniture store, and undertaker. There were also several dry goods stores, a meat market, a fish store, two doctors, and a lawyer. The carriage maker, the shoe maker, and the blacksmith enterprises disappeared, along with other businesses that succumbed to competition. Yet the ambiance has never left the tiny Victorian village, and though most residents commute to make a living, they chose to return to the delightful homespun atmosphere of the village nestled at the foot of the "clear and bright" Helderberg Mountain.

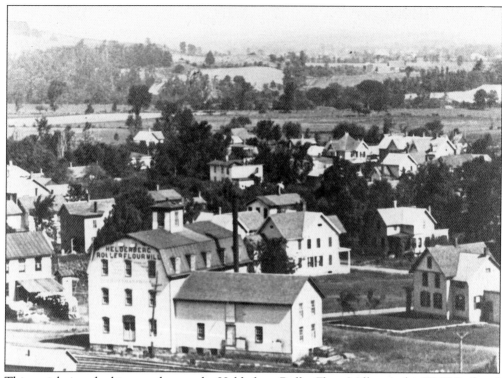

This aerial view, looking north over the Helderberg Roller Flour Mill near the D&H Railroad tracks, was photographed c. 1905. The mill was the second one on that site. The building on the left with an awning was a shirtwaist factory. It later housed the Altamont Soda Works.

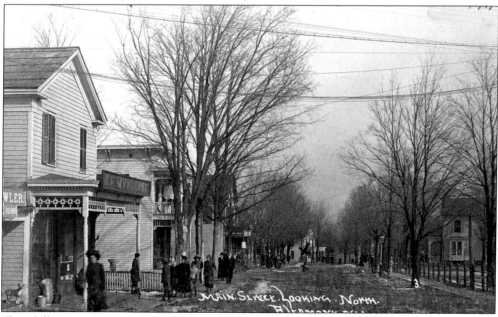

This idyllic scene on Main Street shows villagers who were probably coming back from church on Sunday morning. Note the ladies' hats and men's suits. This early 1900s photo was taken looking north from the railroad tracks. Also note the post fence circling the village green.

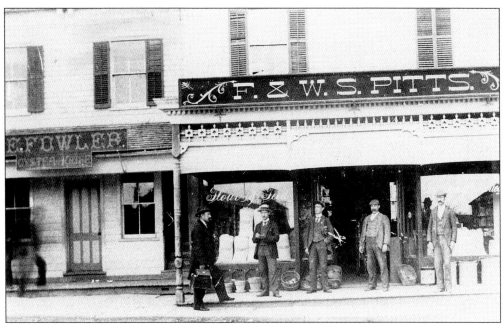

This is reported to be the oldest commercial building in Altamont. In the style of the times, part of the building was set back. Built on Main Street next to the railroad tracks in 1864, one side of the building housed various grocery stores, including Grand Union. The other side was an oyster bar and tavern. Today, the Home Front Cafe and Cindy Pollard's Second-Hand Store operate from there.

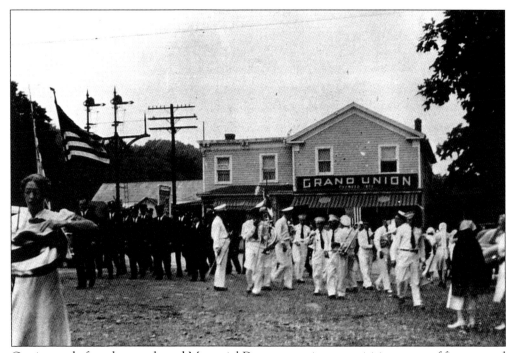

Getting set before the parade and Memorial Day ceremonies are a visiting group of firemen and a band. Grand Union (background) is now a second-hand thrift store.

KNOWERSVILLE HOUSE,

ADAM WEATHERWAX, Proprietor.

ALTAMONT, N. Y.

This Hotel is located near the Depot. It is the largest and most convenient Hotel in the village. Terms reasonable. Special inducements to Summer Boarders and Commercial Travelers.

GOOD STABLES CONNECTED. CARRIAGES ALWAYS READY.

The Knowersville House was built in 1874 by J.O. Stilt, proprietor, beside the D&H Railroad tracks and across the street from its competitor, the Union Hotel (Commercial Hotel). Plans for Altamont's incorporation were made here in 1890. Historians note that Theodore Roosevelt brought his family here for Sunday dinner while he was living in the Governor's Mansion in Albany. Later named the Altamont Hotel by new owner Julius Voss, guests came by train to enjoy the hospitality offered at $8 per week for room and board. The hotel burned in 1928, and Ketchum's now occupies the site.

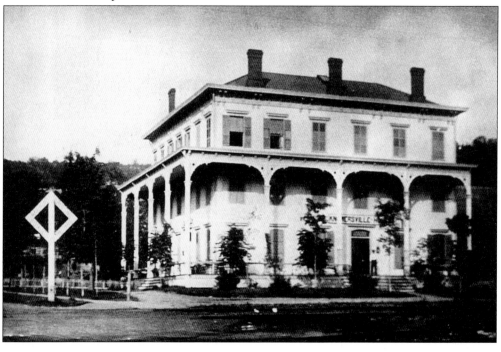

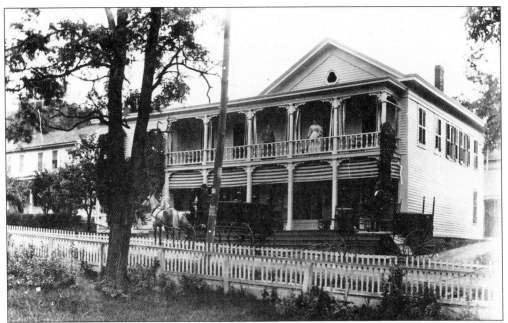

The Fredendall Funeral Parlor on Helderberg Avenue dates back to the middle of the 19th century. M.F. Hellenbeck served villagers with a furniture and undertaking establishment from 1886 to 1895, when his apprentice, Harry Fredendall, purchased the business. Horse and hearse were standard operating equipment until Fredendall made changes by discontinuing the furniture and adding new motor hearses. James Yohey is the present owner.

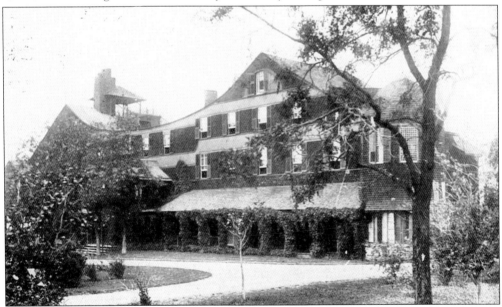

The Kushaqua Hotel (Helderberg Inn) was built in 1886 by Col. Walter S. Church on Route 156, overlooking the village of Altamont. Once owned by the Van Rensselaer landlords, the site is said to have been an ancient Native-American burial ground. In 1918, it was owned by Sisters of Mercy, and was then sold in 1928 to LaSallette Fathers for a seminary. The Peter Young Rehabilitation Center was later built on the site.

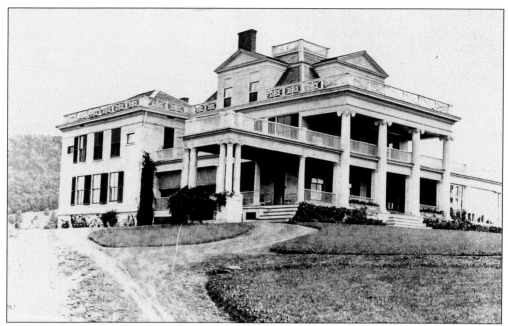

The elegant John Boyd Thacher summer mansion sat high on the Helderberg Mountains overlooking Altamont. It was built c. 1886. Mayor Thacher and his wife entertained dignitaries from the political scene at this handsome mountain retreat. The house was burned in January 1965 as a fire department exercise.

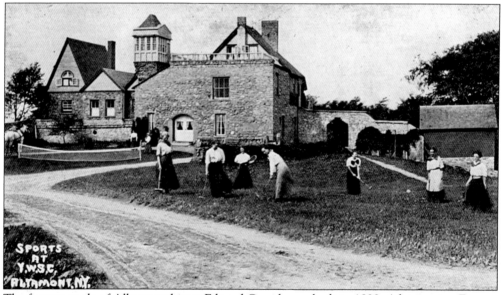

The famous castle of Albany architect Edward Cassidy was built in 1899. After touring France, Cassidy created his castle on the highest part of his estate in the Helderbergs. Built of Oriskany stone, the castle was a national tourist attraction. A hotel was built to house those who came to enjoy the game-cock matches, the quarter-mile race track that featured Cassidy's colts, and to breathe the exhilarating mountain air. After several owners, the castle and several acres of ground were turned over to the Salvation Army, and a Fresh Air Camp was conducted there until the structure burned in 1949.

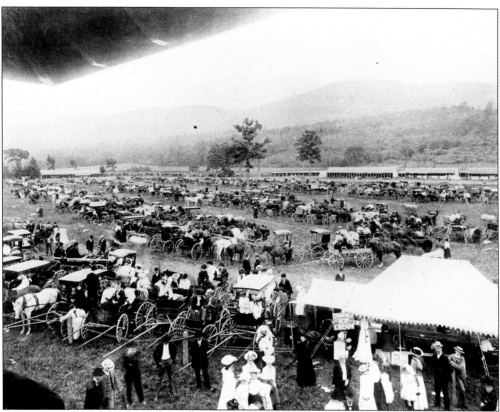

Governor's Day, held on August 17, 1903, was a special opening day at the Altamont Fair Grounds off Grand Street. Note the fancy gowns and hats on the ladies and the men dressed in suits and straw hats. Hundreds of carriages carrying fun-loving fair-goers filled the parking area. Horse sheds can be seen in the background. The first Altamont Fair was held in September 1893.

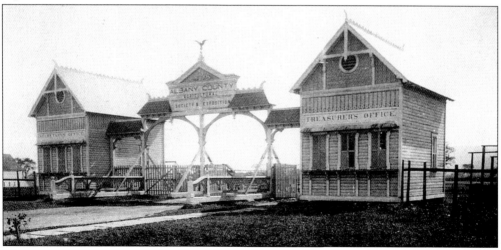

The ornate entrance gate to the Grand Street Altamont Fair Grounds was built in 1905. The small buildings to the right and left outlived their usefulness as offices. Today, they are used as rest room facilities.

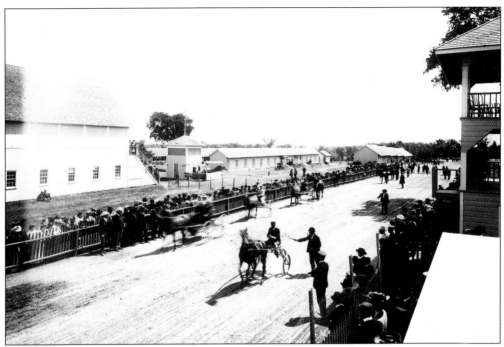

Harness racing at Saratoga brought an end to the harness racing in Altamont. Many of the wealthier local residents participated in this sport. Millard Hellenbeck, a furniture store owner and undertaker, was a popular driver in his cart around the dusty track. This *c.* 1900 photograph shows the newness of the buildings and the wooden fence at track side.

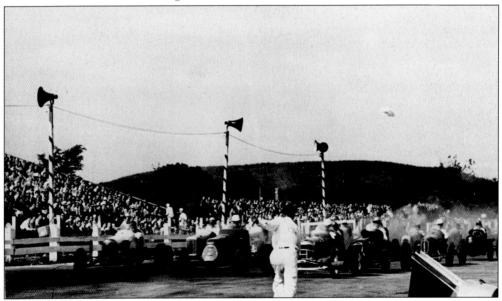

Car racing, livestock shows, and the midway were always big attractions at the fairgrounds. This photo shows the start of the Spring Championship 30-lap race on Memorial Day 1948. The heyday of auto racing was in the 1930s through the 1940s. The one-half-mile clay track was touted as being one of the best tracks in that era. Lee Wallard, the 1951 winner of the Indianapolis 500, rode at the Altamont Fair Grounds track.

Invented in 1892 by Frank W. Ferris, this was one of the earliest Ferris wheels and was one of the biggest attractions at the local Altamont Fair. Today's wheels are much more sturdy than the spindly one pictured in this *c.* 1899 photo.

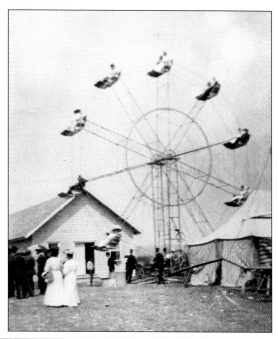

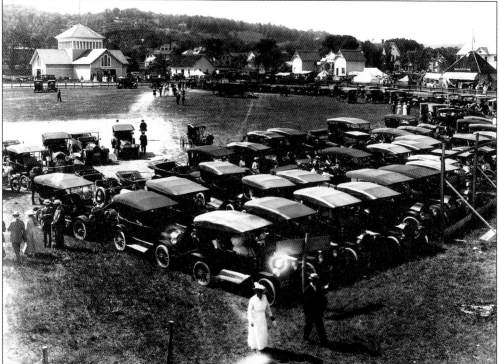

Thirteen years have changed the look of the fairgrounds' parking lot. This 1916 scene shows that the new gas-driven motor cars have replaced the horse and carriage. Yet the ladies still cling to their long dresses and large hats, and the men still wear their straw hats. The Flower Building is in the background, and Albany Mayor John Boyd Thacher's elegant home, now demolished, stands high on the hill on what is presently Leesome Lane.

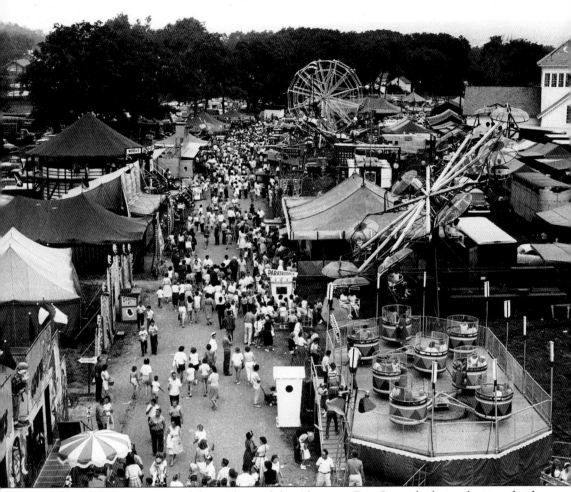

This c. 1955 aerial view of the midway of the Altamont Fair Grounds shows the crowds, the Ferris wheel, the merry-go-round, and other attractions that continue to draw huge crowds from all over the state to Altamont for a week in August every year. In the early years, the fair was only open for three or four days. In the 1920s, the fair remained open for two extra evenings by adding electric lights and, shortly after, fireworks.

Six

BACK ROADS AND COUNTRY BYWAYS

Guilderland's outlying areas often had names and identities unfamiliar to most people today. Osborn Corners is the intersection of Routes 146 and 158 west of Guilderland Center. Originally, the corners were just to the east, where the Schoharie Road passed Osborn Road. First called McChesney Corners, after the family who owned the Appel Inn from 1869 to 1904, the name changed after the property was purchased by Calvin Osborn.

To the northwest of Altamont is Settles Hill, once called Settlesburgh after the 18th-century Sittle or Settle family, who were among the earliest settlers there. Ostrander and Wormer Roads are southwest of Guilderland Hamlet. Fort Hunter is the Carman Road area that was once farmland. In colonial days, Fort Hunter Road began at Old State Road, then followed the route of modern-day Carman Road until it left Guilderland in the direction of Fort Hunter in Montgomery County.

Parkers Corners is the area of Old State Road and Route 158, taking its name from the Parker family, who once lived there. Meadowdale, formerly a thriving community east of Altamont, developed when the Albany and Susquehanna Railroad located a station there to attract tourists to the Helderberg scenery and healthy surroundings.

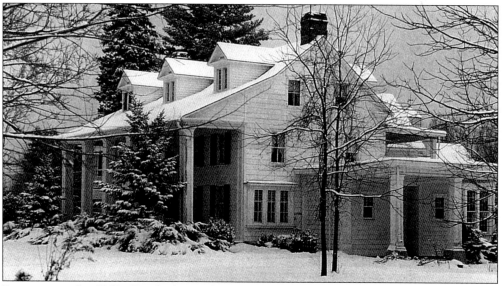

Beginning in the 1760s, Hendrick Appel's tavern was a welcome sight for tired Schoharie Road travelers, who would quaff his famous warming apple toddy. Guilderland's town fathers met here in 1803 to establish a town government. In the 1930s, the building became a restaurant called the Hawthorne Inn and is today a bed and breakfast called the Appel Inn.

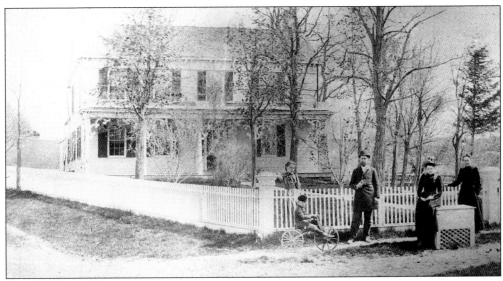

Rev. Bergen Staats, pastor of the Helderberg Reformed Church, poses with his family in front of the parsonage on Osborn Road *c*. 1890. The late-18th-century house served as a parsonage until 1896, when the church moved from Osborn Corners. Occupied as a private residence until the 1950s, it was then abandoned. Under the supervision of three local fire departments, the vacant house was burned in 1967.

The marble tablet above the door reads, "Guilderland Cemetery, 1872, Receiving Vault." This vault is one of five cobblestone buildings erected in Guilderland in the 1860s and 1870s, probably all constructed by R.E. Zeh, the mason documented as the builder of the Guilderland Center Cobblestone School. Located just off Osborn Road, the cemetery itself dates to at least 1849, when a portion of church land was set aside as a burial ground.

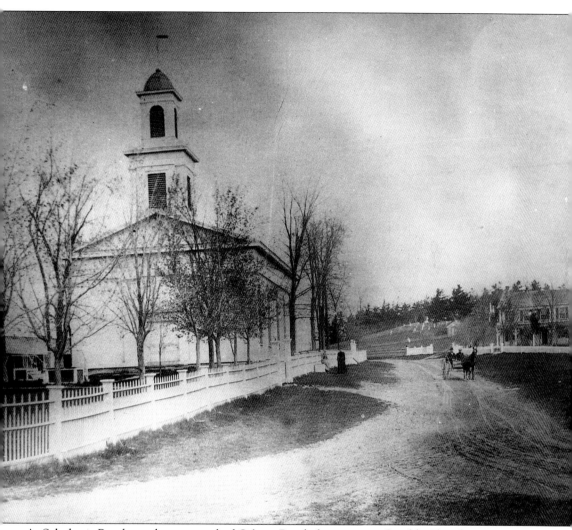

As Schoharie Road travelers approached Osborn Road, the imposing Gamble Church came into view. Across Osborn Road were the parsonage and cemetery shown in this *c.* 1890 photograph. The church was the third Helderberg Reformed house of worship located on this site since the 1760s. First a log "prayer house," then, as the congregation grew, the "Old Red Church" served worshippers. By 1834, a third church was necessary; it was expanded in 1852 so that several hundred church-goers could be accommodated. Large horse sheds (left of the church) sheltered horses and wagons. So popular and influential was Rev. Samuel Gamble, pastor during the 1870s and 1880s, that the 500-member congregation began to call their church the "Gamble Church." In 1896, the congregation split amicably into the Altamont and Helderberg Reformed Congregations, and each built a new church. The old Gamble Church was demolished. Today, underbrush and trees grow on the site where this beautiful church and parsonage once graced the landscape.

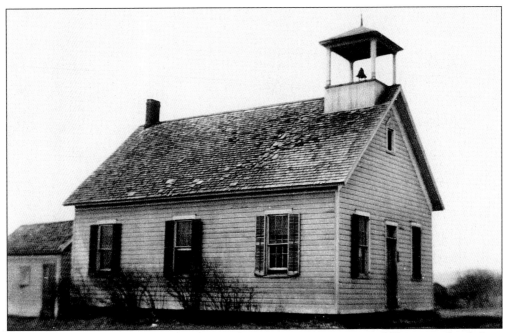

Standing behind the Gamble Church was the District #9 one-room cobblestone school. Lost to fire in 1894, it was replaced by the white frame building shown in this *c*. 1918 photograph. Students attended the Osborn Corners School until 1942, when district residents voted to send their children to Altamont schools. The building continued to be used for community activities until 1953. A year later, the old school building was converted into a residence; it burned in 1969.

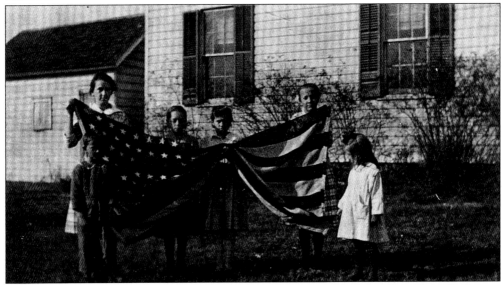

Proudly displaying an American flag outside the Osborn Corners School are Doris Cochrane, Nellie Relyea, Anna Smith, Margaret Hay, Donald Smith, and an unidentified boy. Attendance at the one-room schools not only included the three Rs for the students, but also such highlights as Christmas festivities, Arbor Day celebrations, closing exercises with a class picnic, and participation in patriotic events such as Memorial Day.

Located on Route 158 north of Osborn Corners, this sawmill first utilized water power from Black Creek, then steam power. Built by Rev. Adam Crounse *c.* 1833, its owner by the 1880s was A.J. Tygert, who was described as a "manufacturer of sash, blinds, and doors, and proprietor of a planing mill." His son Peter continued the business. In 1913, the sawmill burned.

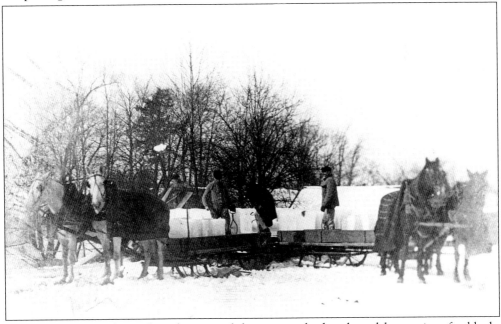

To meet the great demand at the turn of the century by hotels and housewives for blocks of ice to cool their ice boxes, the Tygerts hired men to cut ice from Black Creek, near their sawmill. After being cut, the blocks were piked to the edge and hoisted out by means of a drag. Here, ice blocks are being loaded on a cutter to be transported to the nearby ice house and packed in sawdust.

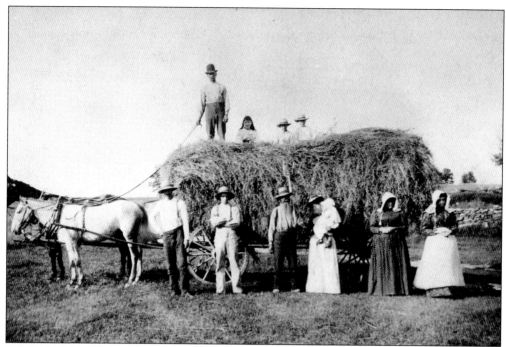

On the Lainhart Farm in the Settles Hill area of town, family members pause after completing the hot, hard task of cutting hay and loading the hay wagon, a job done by hand a century ago. Note the pitchfork. A major source of income for Guilderland farm families was the sale of hay to dealers who paid farmers for their hay by the pound and then shipped it to nearby cities from one of Guilderland's four railroad stations.

The Ogsbury Farm at Lainhart and Settles Hill Roads has been in the Ogsbury-Frederick-Rau family since 1799. Wheat was the original cash crop raised on this farm, but later rye, oats, and hay were grown for sale. By the early 20th century, the farm had become a dairy farm, a transition typical of local farms. A Dutch barn remains on the property. This wintery scene shows that much of Guilderland was still open farmland in the 1930s.

Each autumn, farmers had to be sure that enough firewood was cut to last through the winter. In the Settles Hill area, a farmer named Gray owned a buzz saw powered by an early "hit and miss" gasoline engine, which he took from farm to farm cutting firewood for a fee. Here, on the family farm *c.* 1915, Peter and Willard Ogsbury (left) assist in sawing logs. The two men on the right are unidentified.

Willard J. Ogsbury stands by his horse-drawn milk delivery wagon, near his farm on Lainhart Road *c.* 1910. At first, as he made his rounds, he carried bulk milk that he dipped out with a ladle into one- or two-quart milk cans. Later, the milk was bottled for delivery. He also sold eggs and butter, and fed the skim milk to the pigs.

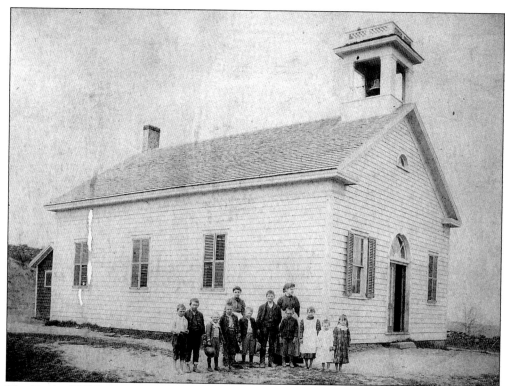

The Settles Hill District #1 School, located at the northeast corner of Settles Hill and Gray Roads, was built in 1854. The teacher and students in this c. 1890 photo are unidentified. In 1891, the Settles Hill District #1 was one of 14 separate common school districts in Guilderland, each with its own schoolhouse. Nineteen teachers were employed to instruct 658 students.

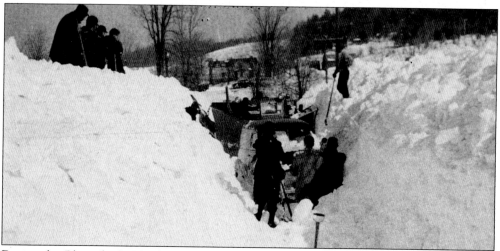

During the Blizzard of 1958, howling winds whipped over 20 inches of powdery snow into huge drifts, making roads impassable, often for days. Schools closed down for a week after the February 16–17 storm and snowmobiles and helicopters had to be used to help people who were stranded. Here, on Gray Road, the Guilderland Highway Department and neighbors attempt to dig out an abandoned car.

116

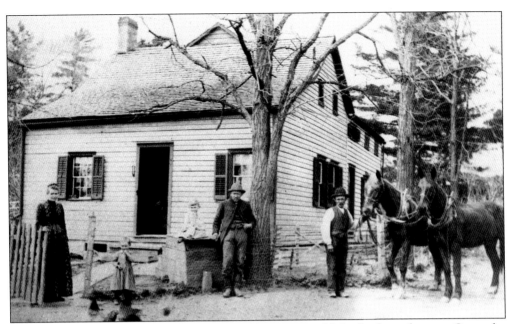

The La Grange family, one of the oldest in this area, established a large farm on Ostrander Road. Seen here in 1891, Myndert La Grange Jr. gathered his wife, Catherine, and his children, Viola and Schuyler, in front of their home. He was a breeder of Morgan horses. His hired hand displays a pair of his prized purebreds.

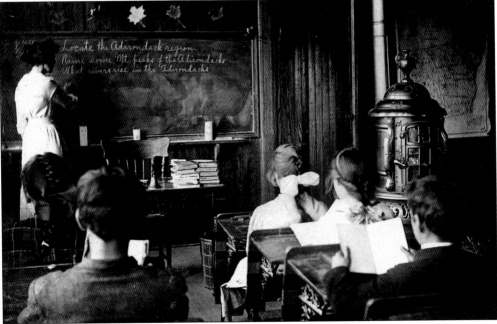

Students at the Wormer Road District #5 School are very attentive as their teacher writes exercises about Adirondack geography on the board. In 1891, Guilderland residents paid a total of $6,074.33 in local school taxes and received an additional $2,658.18 in state aid. That was all that was necessary to run these simple, one-room schools. This one was located at the northeast corner of Route 155 and Wormer Road.

Guilderland's unsung published poet, Magdelene La Grange (Merritt), was born in 1864 near Voorheesville. Her two books of poetry published in 1895 were *Songs of the Helderbergs* and *Helderberg Harmonies*. Magdelene's poems describe her life in Guilderland before the turn of the 20th century. Her poem, "The Drill," depicts delightful scenes of a social gathering at old Frenchs Mill.

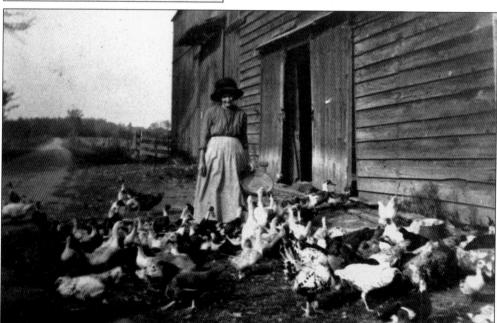

Catherine La Grange is shown here c. 1915 on the La Grange Farm, located on Ostrander Road, doing one of farm women's many chores—feeding the fowl. In addition to ducks, geese, and chickens, farmers often kept guinea fowl, whose raucous cries warned them when intruders were in the hen house.

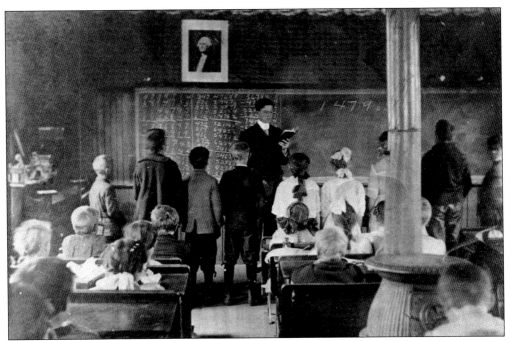

John Gade Sr. listens to recitation by some of his students at the George Bigsbee School District #14 in this 1913 view. In use until 1935, when the Fort Hunter School opened, Bigsbee School was located on the opposite side of Carman Road, west of the later school. Bigsbee's 1876 attendance register still exists, recording winter and summer sessions. The children were out of school in late spring and early fall to help their families with planting and harvesting.

Lovers of pure, tasty apple cider still miss Leininger's Cider Mill on Carman Road, north of Old State Road. Carl and Edith Leininger bought the property in 1942 from Eli Van Wagener and started producing 1,500 gallons of cider a year. By 1949, they were making 48,000 gallons. Albert Leininger continued the family business until 1986, when Indian Ladder Farms took over the mill. The cider mill was torn down in 1989, and Dr. William Tetrault opened a medical practice at the location.

The St. Madeleine Sophie parish dates to 1939 when "George's Place," a Carman Road dance hall, was converted into a chapel. Originally a mission parish, its first pastor was assigned in 1947. Expansion became necessary, and the church was dedicated in 1951. Pictured is the church and its first rectory (left) in the mid-1950s, prior to the construction of the school, convent, present rectory, and parish center.

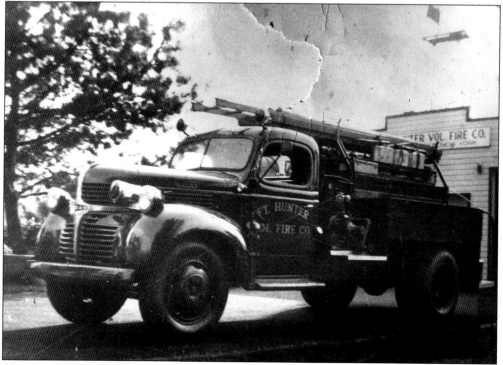

The Fort Hunter Fire Department's first new firetruck, a late 1930s Dodge rebuilt as a fire apparatus, is shown parked in front of the original firehouse on Carman Road. The fire department was founded in 1950.

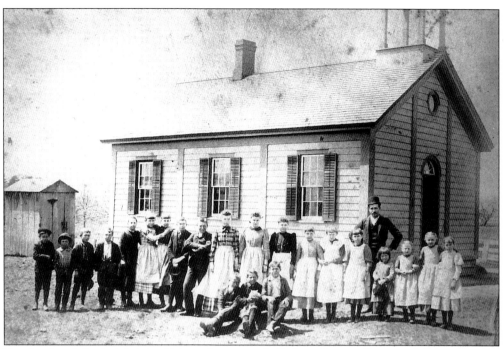

Teacher Jacob Frederick joined his students outside Parkers Corners District #3 School on Old State Road to have this photo taken c. 1890. Behind the school stands the privy, the only rest room facility these one-room schools had well into the 20th century. After the school burned c. 1935, children attended classes at the State Road Methodist Church until centralization in the early 1950s. Then they were bussed to the Fort Hunter Elementary School.

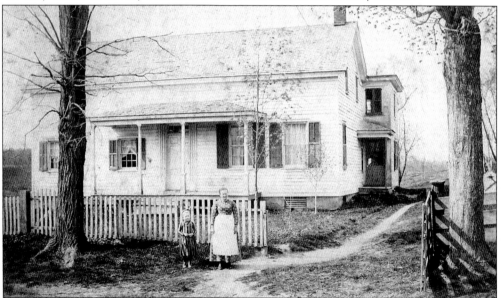

Mary Clute, wife of Parkers Corners' farmer George Clute, and their daughter Ina stand in front of their farmhouse on Old State Road. Mrs. Clute is wearing the typical farmwife's attire of the time: a long dress and apron, uncomfortable for doing household chores on a hot, summer afternoon.

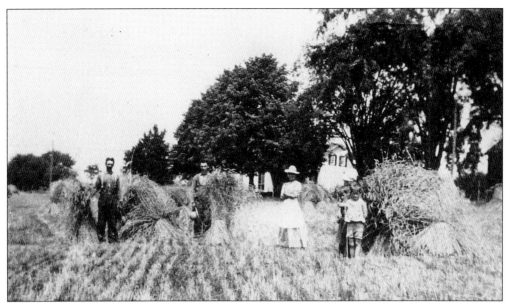

Harvest time meant farmers prayed that the weather cooperated when it was time to take in their ripened crops. Here, members of the Chapell family of Parkers Corner stand in their field *c.* 1910, content that their grain has been harvested and neatly tied in sheaves, ready to be taken to the barn. Their farmhouse stands in the background.

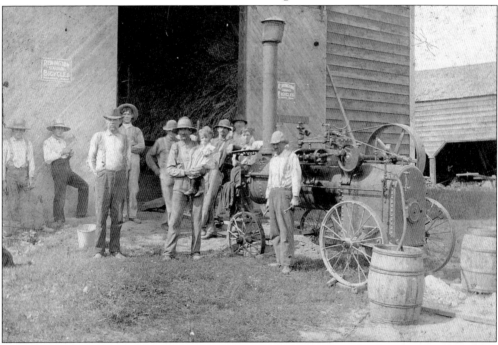

George Clute, a Parkers Corners farmer, was the owner of a steam-threshing outfit, a machine capable of efficiently separating grain from chaff and straw. At harvest time, he hired out to local farmers to thresh their harvested grain, here piled high in Andrew Tullock's barn on Old State Road. In this *c.* 1900 view, Clute poses in front of his machine while Andrew Tullock, along with neighboring farmers and hired hands, leans against it.

"Mud season" plagued country folk each spring, when the snow melted and the thawing ground turned roads to deep mud. These stranded fellows were bogged down at Parkers Corners somewhere in the area of Old State Road and Route 158. Planks laid down on both the Western Turnpike and the Schoharie Turnpike were an unsuccessful effort to overcome the problem.

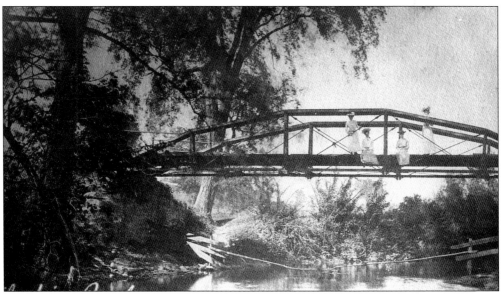

Four young women graced a span called Clute's Bridge on a summer afternoon. Old State Road crossed the Normanskill on this bridge. Postcards such as this were an inexpensive means of communication in the days before the telephone, when mail trains ran frequently. Many of the old scenes of Guilderland that have survived were originally postcards.

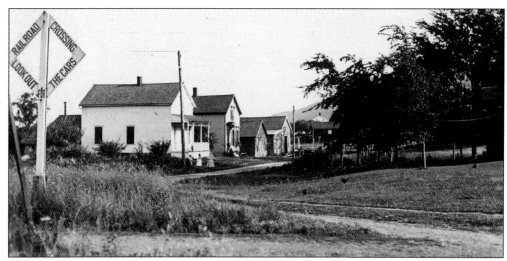

The hamlet of Meadowdale grew around Meadowdale Road, near the railroad crossing. It is pictured in this view looking west toward Helderberg Escarpment. In addition to the railroad station, other businesses included Schoolcraft's general store and post office, two dealers in hay and straw, and George Lauer's blacksmith shop (fourth building from the left.) The station and store stood diagonally from each other, on either side of the tracks.

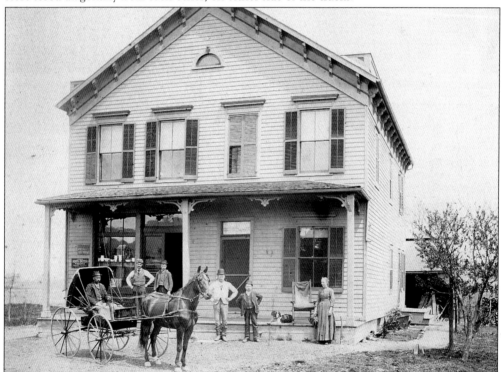

Near the D&H tracks was William Schoolcraft's general store. Mrs. Schoolcraft helped run the store when her husband made his regular circuit of outlying farms, peddling groceries to farmers' wives from a covered wagon pulled by two horses. Until 1926, when it was discontinued, the post office was also located inside this store. It was eventually torn down and the building materials were reused for house construction in Voorheesville.

Weekends and holidays were especially busy at Meadowdale Station when picnickers got off the D&H local to visit the scenic Helderbergs. Most walked up Indian Ladder Road and climbed the ladder to the top, while others hired a horse and carriage similar to the one pictured on this 1907 postcard. Lester Hill's Altamont Livery Stable regularly sent carriages to meet the trains. At day's end, tired from their outing, visitors headed back to Meadowdale Station for the ride home.

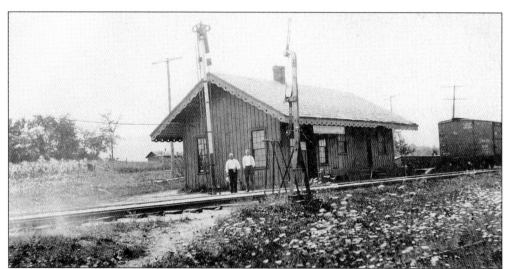

Meadowdale Station was erected in 1864 by the Albany and Susquehanna Railroad; it was a typical country station with a pot-belly stove in the waiting room, a ticket window, and a freight office. Hay wagons could pull up on the platform to the right to unload directly into freight cars. The crane across the tracks enabled passing trains to transfer mail quickly. There were extra sidings and a water tank nearby to supply steam locomotives. After 1931, when D&H ended local train service, the station was demolished.

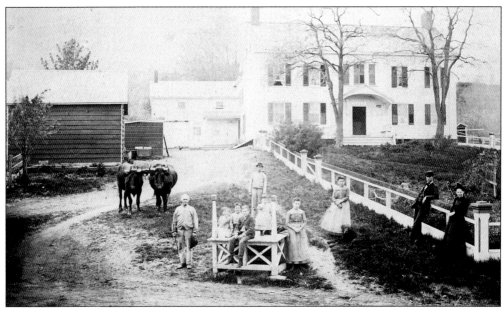

Crounse family members stand in front of their ancestral farmhouse, which was built in 1803 on Route 156 near Brandle Road. Frederick and Elizabeth Crounse, 18th-century Palatine Germans traveling through Guilderland on their way to Schoharie, got no further than the foot of the Helderbergs because, tradition says, the exhausted Elizabeth could not go on. Their farm was established in 1754, and remained in the family for generations. The house still stands today.

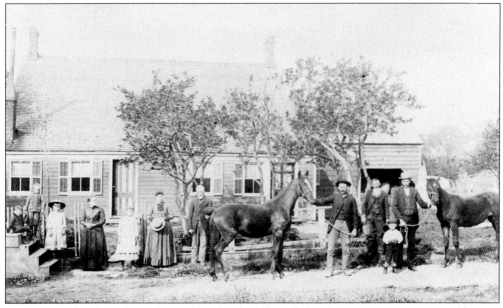

Peter M. Frederick and members of his family followed the then-common practice of having a family portrait taken in front of their home when they lined up beside their farmhouse on Frederick Road c. 1890. Frederick had inherited the house, a 19th-century alteration of the original structure, and a remainder of the Frederick Farm, which was first settled c. 1738 by Michael Frederick and his wife, Gertrude.

Early in the 20th century, Tebalt Frederick's descendants began meeting for lively family reunions complete with good food, contests, and games. Here they pose on Labor Day 1912 at the Tebalt Frederick Homestead, located on Route 156 at Gardner Road. Tebalt, the youngest of Michael Frederick's three sons, died weeks short of his 100th birthday in 1838; he wasn't quick enough to escape over a fence and was gored to death by a rampaging bull.

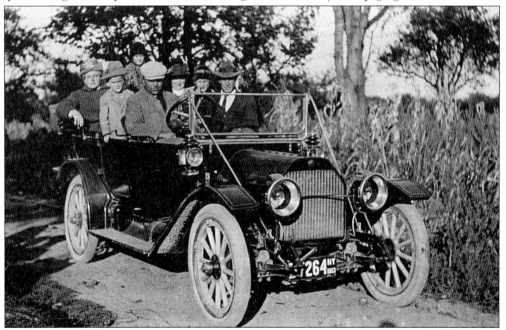

Enthusiasm for the horseless carriage spread quickly. Sitting proudly in their automobile are, from front to back, as follows: Chester Abram and Effie Oliver; (right) Oakley, Marshall, Blanch, and Austin Crounse of Meadowdale. Note the 1913 license plate. At that time, D.H. Whipple of the Altamont Carriage Works advertised Regal Cars in the *Altamont Enterprise*, offering the choice of a five-passenger touring car, fully equipped, for $1,025, or a roadster for $975.

ACKNOWLEDGMENTS

The authors would first like to extend deep appreciation and thanks to late historian Fred Abele, for his insight in beginning the photo archives for the Guilderland Historical Society, and to the Society, who made the photographic images available to us. Images from the collection of former town historian Roger Keenholts are included. This book could not have been published without the photos from these valuable collections.

Many people all over town have shared their photographs and memories of Guilderland's past. We extend our thanks to Louise and Henry Adams, Shirley Carman, Roberta Chesebrough, Arnold and Hazel Crounse, Kenneth Frederick, John Gade Sr., Jim Gardner and Bryce Butler of the *Altamont Enterprise*, the Leininger family, Vera Lund, Reid Northrup of the Altamont Fair Office, Everett Rau, representatives of all the town fire departments and churches, Altamont Village Clerk Kathy Adams, and the many other town residents who answered our calls with information. All either loaned photographs or contributed information.

Finally, we would like to thank the editors at Arcadia Publishing for their counsel and generous patience in guiding us through this exciting experience.

—Alice Begley and Mary Ellen Johnson